LILLIE MAY NICHOLSON
1884-1964: AN ARTIST REDISCOVERED

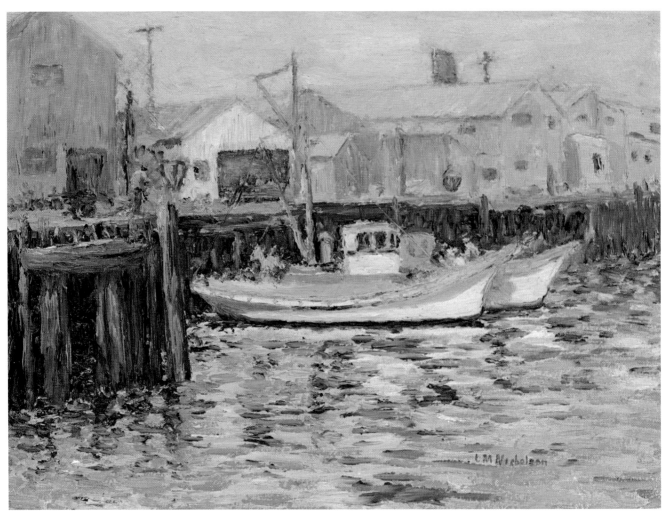

1. FISHING BOATS; FISHERMAN'S WHARF, MONTEREY, CALIFORNIA (Cat. No. 208)

LILLIE MAY NICHOLSON
1884-1964: AN ARTIST REDISCOVERED

Walter A. Nelson-Rees

By Walter A. Nelson-Rees
Foreword by Joseph Armstrong Baird, Jr.

Including a complete catalog of her known works

Published by Oakland, California 1981

Design: Lorrie Fink
Photography: Walter A. Nelson-Rees
Printing: P.S. Press, Oakland, CA
Color Separations: Gregory & Falk, San Francisco, CA
Typesetting: Pacific Typography, Emeryville, CA

ISBN 0-938842-00-5

Cover Illustration: FISHING BOATS; FISHERMAN'S WHARF,
MONTEREY, CALIFORNIA (Cat. No. 208)

To Jimmie
through whom I met Nell and with
whom I found Lillie May's works

Contents

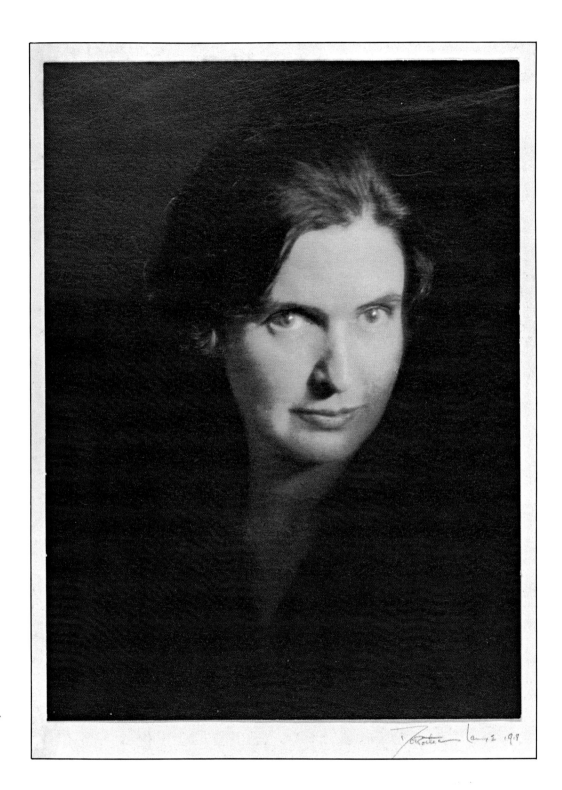

2. Lillie May Nicholson,
 age 34;
 Photograph by
 Dorothea Lange, 1918

Foreword

The life of Lillie May Nicholson suggests only the perimeters of her creativity. Raised in modest circumstances and determined to seek a place in the world, she faced certain basic career limitations of her time. Teaching was clearly the usual "out" for an intelligent, interested person with abiding convictions about work, individual integrity and the wider realm of internationalism. From her earliest school years, Lillie manifested a strong impulse towards art. At first, it was submerged in the gentility of a somewhat limited academic and social life. As travel and living abroad widened the frontiers of experience, she gradually began to respond to something more profound in the natural and artistic world around her.

Endowed with considerable ability, Lillie cannot be called a master virtuoso of the brush. Hers was a sensitive, often a strong, and always capable touch; in her work, there lingers a natural perfume of a simple, straightforward personality. Long before the cause of women's liberation was as popular as it is today, Lillie was a typical manifestation of that earlier twentieth century American firmness of purpose, which made a single life possible and meaningful. She lived alone and liked it. Her one somewhat hasty and late experiment with matrimony proved singleness to be preferable. The mere fact that this woman who lived in the mainstream of the middle class for most of her life could become an aircraft engine mechanic at almost sixty years of age, and that she espoused feelings far beyond her peer-group for the so-called "lower" and distressed members of society, indicates an exceptional resilience of spirit and an insight into the harsh realties of a troubled period. Her ultimate break with all artistic endeavors and determination to destroy this part of her past reiterates an unsparing strength of character.

In her urge to destroy what she apparently considered an aberration of vision, she was wrong; perhaps she knew this, in her heart, as she did not effectively carry through the threat of destruction of her paintings. It is fortunate that she was stopped. It is even more fascinating that a considerable body of her aesthetic endeavor was stored in an old wash house "time vault," and that, through a series of coincidences, it was finally discovered — leading to re-evaluation of her entire career. For Lillie May Nicholson has much to say in her direct, often fluent manner of pictorial speaking. While many works have a lyric and feminine quality, there is also a masculine roughness in some of her painting that was only occasionally overtly revealed in her life. In some of her most powerful works, she identified with working men as subjects as she did in her wartime activity as a

mechanic. The psychological undertones are compelling; someday, they may be more clearly understood. Beyond the teatime mentality of the members of that colony at Pacific Grove-Monterey-Carmel in the 1920s and 1930s, there can be seen an artist and social radical who flowered for a brief time and renounced emancipation for a long hibernation in quiet non-existence.

Lillie did not seek the artistic acclaim which burdens so many creative talents; she seemed to feel it was not important to her. What was important was a special kind of aesthetic development — logical and of clear definition. From the earlier interest in pure landscape of a more refined type, there gradually emerged the direct, painterly land-scapes of the Pacific Grove years, with the vivid studies of fishermen which may date to that era or later. While she had explored a chopped-stroke technique and quasi-Impressionist approach to subject before 1923, it was particularly in the ten years at Pacific Grove that a modified French and American early-modern approach was evolved. In certain works, Lillie May Nicholson parallels the work of the Society of Six — many of whom came to Monterey about this time. There is a fresh, spontaneous, Impressionist-Fauve-Expressionist, but Californian quality to her work, which links it to the more progressive trends of contemporary Bay Area painting.

It is engaging to speculate what might have happened to this unpredictable woman if she had gone on from her wartime mechanical endeavors to study once again at the San Francisco Art Institute — during the Douglas MacAgy and Clyfford Still era of revitalization. Perhaps, more meaningfully for her *oeuvre,* it is relevant to note that Nicholson did not fall into the bland social realism of many Northern California artists in the 1930s. Instead, in one of her many periods of recycling, and withdrawal from a too polite social milieu, she walked the streets of Oakland — seeking solutions to the ills of society, discussing them in her drawings and in sometimes cryptic political comments.

Like Selden Connor Gile, Nicholson had a complete independence of attitude. Both artists were "loners," out of the mainstream of their era in attitude and artistry; both created works of fine personal sensibility. Both, curiously, also showed no particular care in the tending of their creative harvests. Gile chronicled the East Bay, Marin and Belvedere; Nicholson described the greater Monterey area — almost exactly contemporaneously. It would be fatuous to compare either artist to the giants of the later nineteenth and earlier twentieth centuries; their own modest disclaimers would be the first to be heard. Still, both spoke out clearly and thoughtfully about a basic painterly commitment that was unusual in their time. Color remained a prime concern; formal expression came second. Lillie May Nicholson had a more traditional training and the inestimable advantages of worldwide travel.

It is significant that this plain school teacher responded more eloquently to the ideas of artists like Monet and van Rysselberghe than most Californians. If she were neither a Monet or Cassatt, she was in advance of the picturesque generalization of much local art. Her strong, often vibrant and sometimes harsh brush stroking imparted a vivacity to her paintings which most of the Monterey Cypress and Eucalyptus tree masters failed to achieve. Like her earliest important teacher, Piazzoni, Nicholson saw with clear eyes what was special in any milieu for her talents. Breaking decisively with the ''tobacco juice'' monochromaticism of Martinez, she also pushed on beyond the elegant decorative rhythms of the Mathews.

Whether in France or California, the artist expressed an unusually honest, yet always attractive impression of nature — and man. It is a combination of this artistic candor and her own staunch inner convictions, with the often sophisticated recollection of internationally relevant aesthetic developments, which places Lillie May Nicholson in a special position in the California art world.

<div align="right">Joseph Armstrong Baird, Jr.</div>

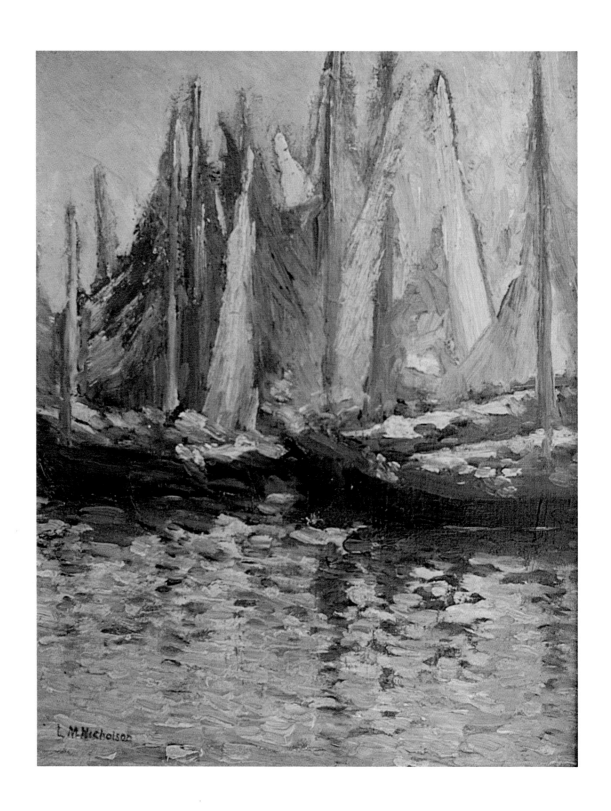

3. FISHING BOATS,
 VENICE, ITALY
 (Cat. No. 61)

Introduction

Before this was written, the paintings of Lillie May Nicholson were known only to family members and a few close friends who own her works. All of these had been acquired during the artist's lifetime. My friend, James L. Coran, and I now recall having seen a few additional works at some auction house, art gallery or shop, but it was not until April of 1979 that we became interested in her paintings and discovered a large collection of them.

During a visit in San Francisco to an early acquaintance of the artist, we were intrigued by the character and subject matter of the painting shown on the cover of this book. (Ill. 1) Somewhat later we discovered that it depicts a portion of the east side of Wharf Number One, better known as Fisherman's Wharf at Monterey, California. We learned that L. M. Nicholson had been born near Watsonville, and that she had painted at one time in Pacific Grove, also on the coast and a few miles south, but that she had died several years ago. We were still more curious on hearing that other works by this artist were located on the family ranch near Watsonville and that, indeed, a visit there to view them might be arranged through a niece of the artist, who lived in Sacramento.

Some weeks later, the visit took place. We met the artist's only living sister who graciously showed us a large number of Nicholson's works hung throughout the family ranch house. While talking about the artist and studying her work, we expressed interest in owning a painting by her and were offered a number from which to choose. All were attractive. On learning that Miss Nicholson's paint boxes, easels, palettes, etc., might still be on hand, we were directed to a nearby wash house. It was there, after finding the painter's tools, that we accidentally came upon an additional large collection of L. M. Nicholson's paintings stored in two old trunks which had belonged to her. Literally dozens of works had been stored there for over forty years, after Miss Nicholson closed her studio and ceased to paint about 1938. There were not only the professional works of her Pacific Grove - Monterey period, but sketches done in her youth, works of her student days in San Francisco, European works, and, curiously also, a thick folder of pencil sketches executed in the years 1934 to 1937, depicting persons in Oakland, and made toward the end of her career as an artist.

It was clear that here was the large part of the work of a painter who had received little recognition during her lifetime and who had gone unnoticed since then. That her paintings were relatively unknown was not so surprising when it became apparent that adequate infor-

mation on the painter was nonexistent. There is nowhere, known to us, any mention of this artist by name: not in any of the numerous listings, reviews, exhibition catalogues, or historical accounts of artists working in Northern California during the earlier twentieth century — particularly on the creatively fertile Monterey Peninsula. This area includes Monterey, Pacific Grove and Carmel. Granted, there were many painters active in that area in the 1920s and 1930s — some good, and some not so; there continue to be many artists active there today, but few of her contemporaries of consequence have gone as unnoticed as L. M. Nicholson.

There is one exception to the above. A rather poignant oversight was discovered which is typical of the contretemps surrounding the lack of publicity afforded the works of this artist during her career. The only known review to date of a work by her is one which appeared in December 1927, simultaneously in the *Carmel Pine Cone* and *Monterey Peninsula Herald.* In an article by an anonymous critic reviewing the "Thumb Box Sketches on Show at Art Association (Carmel)" one reads that, *"Fishing Boats, Venice,* by T. (sic.) M. Nicholson is one of the most beautiful paintings in the show." Curiously, the name Tillie M. Nicholson was then also listed on the contemporary membership roster of the Carmel Art Association. Undoubtedly, however, this painting is one of Miss Nicholson's, owned by the author today. (Ill. 3) Upon the discovery of this review, a closer examination of writing on a label attached to the reverse of the painting states that it was "Shown in Carmel Xmas 1927 Santa Cruz and Arizona 1927." The painting is also clearly signed "L. M. Nicholson" in the lower left-hand corner!

This book is intended to introduce Lillie M. Nicholson properly and to correct that oversight. We have enjoyed discovering the person and the work of Lillie May Nicholson. She was a teacher and an artist; we also learned that she worked during her later years as a war-time aircraft mechanic. Only her art remains. We wish to reveal its scope and quality in order to allow viewers not only to see her paintings but to relate them to the work of fellow artists who were on the scene during her relatively short productive period as a painter. We are convinced that during this time she created numerous evocative works, which deserve to become a part of the artistic heritage in California.

Walter A. Nelson-Rees
Oakland, California
1981

Acknowledgments

A friendship of many years led unexpectedly to the discovery of the works of Lillie May Nicholson. (Miss Nicholson signed most of her works with her name and the initials L.M.; I have used this designation where appropriate.) For this awakening of interest in the artist, I am grateful to Nell Kortright Evey of San Francisco. Members of the Nicholson family have volunteered their paintings to be studied and recorded. The extent of their assistance can be gleaned from the credits to owners which appear in the catalog. To the friends of the family who allowed me to view their paintings, I also offer my thanks. In a real sense this book is a tribute not only to Lillie May Nicholson, but also to her sister, Emma Hazel Nicholson, through whom I came to know the artist. Her many recollections of dates and places in the life of her sister form the basis for the integrity of this study.

Many officials in various capacities offered vital statistics and other valuable information on the artist. Most of these are acknowledged individually among the notes. I regret any omissions and offer my thanks to all, through this completed work. A special compliment goes to Betty Lochrie Hoag McGlynn who ferreted out the only known public review of a work by L. M. Nicholson, which had been erroneously ascribed to a T. M. Nicholson. Finally, I would like to thank June Braucht, Director of the Monterey Peninsula Museum of Art, for recognizing at once the importance of these paintings to the art of Monterey. After viewing many of the works, she suggested an exhibition in 1981, in order to present to the public the works of this artist which, for so long, lay dormant. A separate exhibition catalog is contemplated for that occasion.

Do *fascinating* things! Not smart ones! Nobody ever tucks a *smart* sketch under his arm and runs home with it. Paint your own impressions. Tom and Dick won't like the result; but, by and by, along comes Harry, who says, "By Jove! I've seen that very thing in Nature!"

WILLIAM MORRIS HUNT'S TALKS ABOUT ART

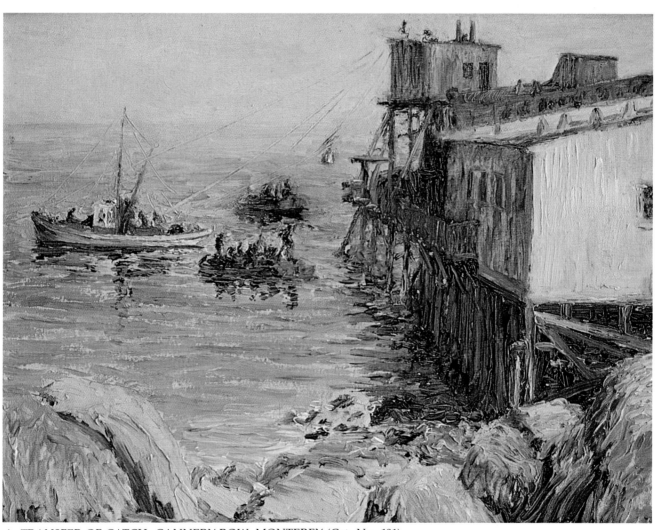

4. TRANSFER OF CATCH, CANNERY ROW, MONTEREY (Cat. No. 101)

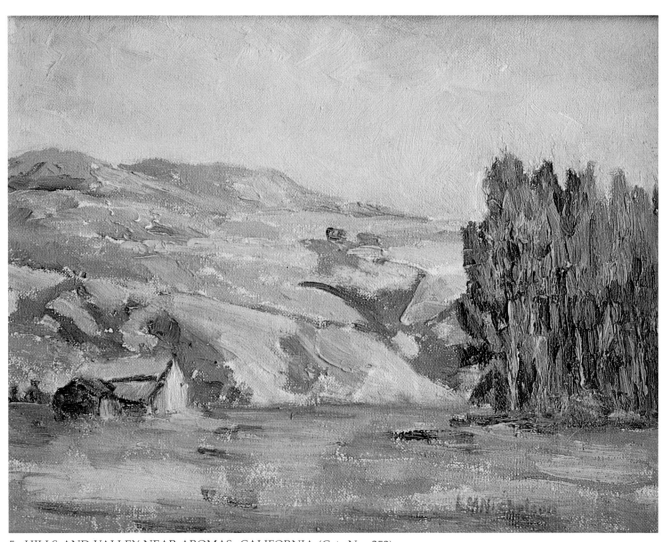

5. HILLS AND VALLEY NEAR AROMAS, CALIFORNIA (Cat. No. 252)

LILLIE MAY NICHOLSON
1884-1964: AN ARTIST REDISCOVERED

CHILDHOOD AND YOUTH: 1884-1907

Lillie May Nicholson, known to her family and friends as Lillie or Lillian, was born on August 29, 1884, on her parents' ranch near Aromas, California — in the hill country, ten miles east of the Pacific coast.[1] It was a sprawling apricot and apple farm along San Juan Road between Watsonville and Mission San Juan Bautista. The area was referred to as Dunbarton and, early in this century, when mail arrived at Aromas for the Nicholson ranch, it was directed to Dunbarton. (Ill. 5) An early reference to the ranch or its location called it *Carneros*, the Spanish for sheep. This was at that time also the name of a school district near Aromas named after a Spanish land grant situated three to four miles southwest of Aromas.[2] The Nicholsons' ranch house still stands and is occupied by a sister of the artist. The modest wooden building is surrounded by well-groomed garden beds filled with old-fashioned flowers, shrubs and a huge California scrub oak which protects an ancient water tank. Other relatives live in close proximity on the Nicholson ranch.

Lillie's father and mother had come to California, each at age sixteen — he from Scotland and she from Minnesota. Murdoch and Emma Cole Nicholson had five daughters and two sons. The rural home on the ranch which was founded in 1867 provided a friendly and hospitable environment where "a pot of beans was always on the stove" and friends, young and old, were welcome.[3] The daughters were given an opportunity for a higher education; the sons, in contrast, directly assumed responsibilities on the ranch. Four of the girls became teachers and one remained at home to help with the house work. Of the children, Lillie May was to move farthest afield during her lifetime. To relatives who remember her today, she remains a refined and distinguished personality. Miss Nicholson's early schooling took place near Aromas at the Carneros School which offered a nine year curriculum. Moving to San Jose, where she lived with the Coles, her maternal grandparents, she graduated on June 21, 1907, from the California State Normal School and began, at age twenty-three, her career as a school teacher.[4] Her first asssignment, as such, was at the Aromas Rock School, near the Nicholson ranch, in the fall of 1907.

The first indication of formal training in art comes from four small drawings, three in pencil, one in pen and ink, the latter dated 1902, when Miss Nicholson was eighteen. On one of these sketches appears the notation "good, but weak . . . (see Earliest Known Studies p. 84).

Most likely, these drawings, one of which is a copy of a picture of a clock and a book printed on one-half of the sheet of paper to be copied by the student on the other, were executed while still at the Carneros School.

HAWAII: 1908-1910

On what was to be the first of three known trips abroad, L. M. Nicholson embarked from San Francisco on the steamer *Siberia* for Hawaii, on Christmas day, 1908. She spent a year and a half teaching there. One of two letters written by this "California school ma'am" to her father on the ranch, and reprinted in the *Salinas Daily Index*, describes her voyage to the Islands in 1908; the other gives lucid impressions of this young woman traveling to and living there alone, in that American paradise.[5] It was a considerably new experience for her to live in Honolulu, and it is charming to read her comparisons of this place, with the other town she knew well, namely San Jose, California. Her enthusiasm is expressed in crisp, reportorial but good English. Originally scheduled to teach at North Kona, on the island of Hawaii, on her arrival she was told that another teacher had occupied that post. The Superintendent thus placed her at the Normal School in Honolulu where she stayed presumably during her entire sojourn in Hawaii. From the school, where she taught arithmetic and geometry, she had a magnificent view of the harbor and enjoyed watching the ships come and go. She appeared to have made friends in Honolulu and on one occasion she and a group of them toured an American war ship in the harbor.[6]

WATSONVILLE: STUDIES IN WATER COLOR: 1910-1911

It is known that on her return from Hawaii in 1910, Miss Nicholson was engaged as a teacher for two years at Watsonville.[1] It is here that she began to take lessons from L. Minnie Pardee, a water colorist of considerable renown in the area. Two of Pardee's works, done years

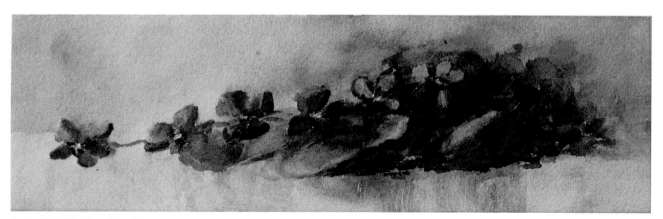

6. VIOLETS (Cat. No. 1)

later, are known. Both are paths through the redwoods; one is entitled *Richdale, 1921*. Of Nicholson's work during this period, there remain four panels of flowers in water color, including a still-life of violets, said to be her first water color, (Ill. 6) and two landscapes. The latter depict a country road along a wooden fence, and fields, a tree and a pond in fall. (Cat. Nos. 2 to 6)

JAPAN: 1912-1915

Very little information about Miss Nicholson is available for the years 1912 to 1916. In late 1911, or perhaps early 1912, she traveled to Japan. Earlier, on leaving San Francisco for Hawaii in 1908, she had been impressed with the "coaling operation" on the steamer *China*, lying in a berth next to the ship taking her to the Islands. Now, several years later, in a handsome album which she created as a souvenir from hand-colored post cards of Japanese scenes, there is one card described by her as depicting "the ship *Cleveland* being coaled at Nagasaki (just as we saw it last Christmas!)" This means that her departure for Japan probably took place around December 25, 1911. (Ill. 7)

In retrospect, these harbor scenes appear to have made a lasting impression on Nicholson. This general subject matter is one which would occupy her attention several years later as an artist in Pacific Grove, California — perhaps not the coaling "of an ocean-going vessel," but certainly related activities involving the sea and boats and men working in the harbor at Monterey. (Cover and Ills. 1 and 4) Significantly, however, the album's cover, entitled *Japan*, was then decorated with delicately drawn Japanese irises, hand-painted in water colors.

That she taught in Japan and became "well-known as a teacher in English in the Commercial School in Kyoto . . . and educational circles in Japan . . ." is seen from a brief notice in an English-language newspaper in Japan.[7] The notice also indicates that Nicholson had traveled from Japan to Europe and back during her stay in the Orient, and that she was robbed of her possessions, including her passport, from her cabin aboard the *Sada Maru* in Hong Kong harbor on June 1, "while returning from Europe . . ." Shortly after this occurrence, and before her return to the United States, presumably in the autumn of 1915, she resided at Yokohama. An interesting photograph, most likely of this period, shows her seated in a rickshaw drawn by a coolie.[6] She returned from this trip with a good many oriental gifts for the family in Watsonville.

Miss Nicholson also studied art in Japan, her teacher being a certain J. Taguchi. A small landscape in oil by this woman, a gift to Nicholson now owned by a relative, depicts a decidedly occidental type of landscape painting with barren trees and a figure on the path, reminiscent of a Barbizon pastorale with shepherd and flock. It is signed in Roman letters and dated 1913. Nothing is known of Nicholson's own art work in Japan.

7. Coaling of the CLEVELAND

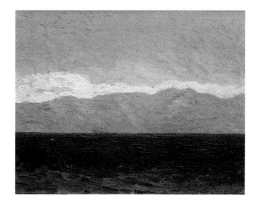

8. RED HOUSES AT INLET (Possibly Mt. Tamalpais beyond; dated 1920) (Cat. No. 23)
9. LANDS END, SAN FRANCISCO (Cat. No. 22)
10. LAKE TAHOE (Cat. No. 31)

SAN FRANCISCO INSTITUTE OF ART 1916-1921[8]

The Panama-Pacific International Exposition, in the Marina District of San Francisco, and the San Diego-Panama-California Exposition, in Balboa Park, took place in 1915 and 1916.[9] These two events were of considerable significance to the art world of their time, most especially in California. They were the inspiration for smaller art exhibitions at galleries and cities throughout California before and after the main expositions. The northern exposition's first part lasted from 10:00 o'clock on February 20, 1915, until the night of December 4, less than ten months later; "about two million persons tasted its delights."[10] Artists from many countries and the United States were represented in these exhibitions; and the formidable art display must have been viewed and discussed by many local artists. L. M. Nicholson, however, was probably still in Japan during this time. The San Francisco Exposition was extended, in a second part, from January to May, 1916; it was here that the painter, Piazzoni, was represented by a painting titled *Lux Eterna*.[11a]

In the memory of some members of the Nicholson family today, the art teacher she mentioned most was Piazzoni. This was undoubtedly Gottardo Piazzoni (1872-1945), the Swiss emigrant of Italian descent, who came to his father's ranch in Carmel Valley as a thirteen year-old boy in 1887.[11b] Piazzoni was to become a leader among painters in "the second generation of California Painters," and formed a highly regarded trio, along with Maynard Dixon (1875-1946) and Armin Hansen (1886-1957), "because each is intensely individualistic, but little influenced by the work or opinions of others." "Further to him interest lies with no lack of sympathy, less with man than with nature."[11c] As we shall see, the paintings by Nicholson, executed under the tutorship of Piazzoni, are devoid of human figures. All are meticulous land and seascapes — either around the Bay of San Francisco or, in one instance, at Lake Tahoe in the Sierra Nevada, with one or two, perhaps, at the beach near Carmel. A transition period, inspired by a trip to Europe, when human figures were added to urban and country scenes, appears to have followed upon classical figure painting and design studies at San Francisco. This change, incorporating and eventually concentrating upon the human figure in action, was to become quite the most accomplished expression of this artist's talents.

The excellent records in the archives of the San Francisco Art Institute, collected after the 1906 disaster, revealed that Lillian Nicholson registered there as a student for the first time on July 17, 1916, to attend the summer session lasting six weeks.[8] It is known that Piazzoni not only taught privately in his studio in San Francisco, but also at the Institute. Whether Piazzoni taught during that first session is not known, but Nicholson took figure painting, illustration, and outdoor sketching. In 1917, she enrolled as Lillie Nicholson for all day sessions

11. BOATS – BELVEDERE (Cat. No. 27)

12. REFLECTIONS, TIBURON (Cat. No. 28)

from June 25 to August 4, and in 1918, as Lillian, she participated in the summer sessions from June 23 to August 3, and again from September 3 to September 18 on one-half days. Gottardo Piazzoni taught at the first of these; an article in *The Wasp*, for 1918, recorded his activities.[11d] We read about "Piazzoni's duties as a teacher in a class in Landscape; Landscape and Composition all day Friday. Mr. Piazzoni will conduct a course in landscape painting at beautiful and picturesque points about the bay, to be designated by him each week. This will give serious study of open air effects. Informal talks on landscape will be included." Miss Nicholson's professional works at a later date were probably all painted outdoors, rather than in the studio.

Miss Nicholson gave her local address as 1010 Haight Street, San Francisco, in 1916 and 1040 Bush Street in 1918 and 1919. These were probably her residences during summer school, as it is known that she was teaching full time during those years, at first in Santa Clara (October, 1916 to May, 1919), and later in Oakland (August, 1919 to September, 1922.[12] Again, Piazzoni taught landscape painting and composition during 1919, 1920 and 1921.

A number of charcoal sketches remain of her early schooling at the Institute, probably during 1916. They were most likely drawn in portrait and figure painting classes; none is dated but one bears her earliest known signature as L. M. Nicholson. (Cat. No. 17) As we shall see, she returned to the art of portraiture at the end of her painting career in the mid and late 1930s.

A substantial collection of paintings in oil, on cardboard, signed L. M. Nicholson, also remain of these student days. None is dated, except one marked 1920 in pencil; but they are located in her handwriting as being around San Francisco Bay. (Ill. 8) This, and the particular type of artist's board utilized, sets them apart as a group. Most important are the somber, almost geometric yet well-composed pictures of *Mount Tamalpais, Lands End,* and *Mount Talac, near Lake Tahoe, California* (sic). These paintings show water but no figures. (Ills. 9 and 10) Two extraordinary scenes, one at Tiburon, and the other at Belvedere, in Marin County, along with several of San Francisco Bay, show notable attempts at a form of Impressionism and of Whistler-like water-mirrored reflections painted from locations in the waters of the Bay.[13] (Ills. 11 and 12) Paintings of coastal waters and marine action would continue to be developed to create the high points of her career.

Miss Nicholson was an adult when she attended the Art Institute in San Francisco. She was thirty-two years old on her return from Japan — an established teacher in general fields and, by virtue of her travels and residence abroad, a fairly sophisticated and mature person. Connections made at the Art Institute were certainly those of a student on an intellectual par with her teachers. An elegant studio portrait exists of Lillie May Nicholson for which she sat in 1918. (Ill. 2) In addition to being a dramatic photographic study of Nicholson, it has the distinction of being among the earliest known portraits created by Dorothea

Lange after her arrival in San Francisco from New York in 1918. The portrait is dated that year and signed by Lange; two copies of it are known to exist.[14] Miss Lange was then twenty-two. Her brilliant career in photography subsequent to her arrival in California is well documented. She was married to the painter Maynard Dixon from 1920 until 1935, being his second wife; she died in 1965.[15]

EUROPE: 1921-1922

A letter from the Institute, addressed to Miss Nicholson at the Delmar Inn, 15th and Jackson Streets, Oakland, California, could not be delivered and was returned in June 21.[8] We know the reason; she had been given a leave of absence from the Oakland School System; she was in London, England on June 21, 1921, in Scotland, July 15, and in Paris, December 11. Later, she was in Shanghai on June 6, 1922.[16] It is clear that she had planned a year long journey around the world, because from Paris, in June, she wrote to Watsonville that she was "asking for another six-months leave-of-absence from Oakland and *think* I'll get it." Apparently, she did not get it, however, as school records indicate that it was disallowed and that she quit in 1922, after her return to America. She had taught in Oakland at the Allendale and Longfellow grammar schools. In a postcard from Paris, she was pleased to hear that the "Peace Treaty in Washington was doing so well" — reference to the meeting at the capital called by the United States in the winter of 1921-1922, on limitations of naval armaments.[17]

It is not known whether they met in Europe, but Gottardo Piazzoni, as often before on travels abroad, visited many places, including Paris, during his six-weeks sojourn in 1922.[11e] Miss Nicholson traveled widely as well. In Scotland, she went to visit with her father, Murdoch Nicholson's relatives near Stornoway. Whether the Nicolsons "without an h" and the Nicholsons "with an h" were closely related, was not firmly ascertained, but L. M. Nicholson ("with an h") enjoyed visiting all of them and viewing the Nicolson Institute in Stornoway, which "was considered very fine" and "probably had some forty teachers in it." From London, she wrote about her stay at a boarding hotel where she lived in a "lovely big front room" which, "with breakfast and dinner, could be had for about $2.10 per day."

Artistically, she created works near Etaples, France, on the coast south of Bourgogne, in the Strait of Dover, near the river Canche, which flows to the sea at Etaples, and along waterways in Northern France, Paris and Venice. Persons appear for the first time in many of her oil paintings — people with ships and water. We do not know specifically what led Nicholson to Etaples, but judging from the number of works which she painted there she must have resided in or near there for some time during her year-long stay in Europe. Interestingly, we know of two other American painters who had worked there prior to Miss Nicholson's visit. C. Harry Allis (n.d. — 1938) lived at Etaples and at Grez from 1904 to 1912,[18] and Francis Henry

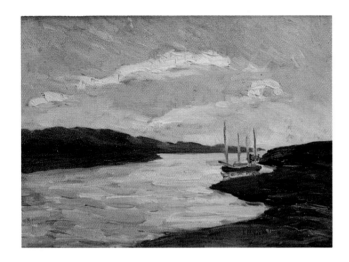

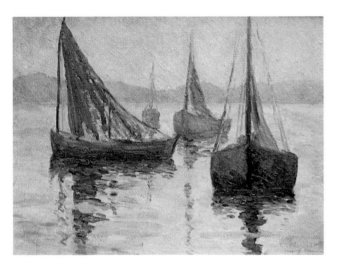

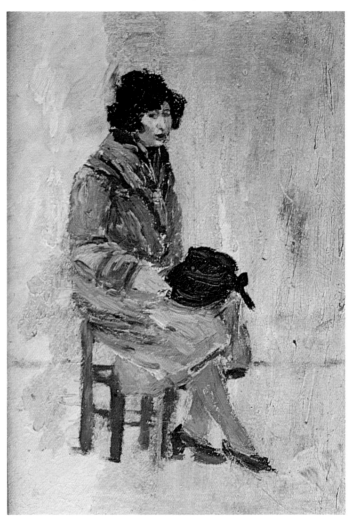

13. (left, top) CANCHE RIVER, ETAPLES, FRANCE (Cat. No. 39)
14. (left, bottom) SAILING VESSELS, ETAPLES (Cat. No. 36)
15. (right) WOMAN WITH HAT (Cat. No. 38)
16. (opposite page) ETAPLES WATERFRONT AT NIGHT (Cat. No. 43) (Special notation: from Ten o'Clock)

. . . *when the evening mist clothes the riverside with poetry, as with a veil, and the poor buildings lose themselves in the dim sky, and the tall chimneys become campanili, and the warehouses are palaces in the night, and the whole city hangs in the heavens and fairyland is before us – then the wayfarer hastens home; the working man and the cultured one, the wise man and the one of pleasure, cease to understand, as they have ceased to see, and Nature, who for once, has sung in tune, sings her exquisite song to the artist alone, her son and her master – her son in that he loves her, her master in that he knows her.* [13]

17. HAYSTACKS AND POPLARS,
 ETAPLES (Cat. No. 48)

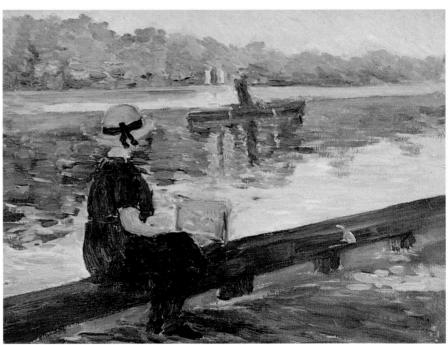

18. SELF-PORTRAIT ALONG THE SEINE
 (Cat. No. 56)

Richardson (1859-1934) painted there.[19] From Etaples, we have fishing vessels in the river, stark buildings at the water's front, at times children, and on one occasion, a beautiful, well-dressed and coiffed young woman seated as if for a portrait. (Ills. 13, 14 and 15) This picture before cleaning was pencil-marked *15 rue Lafayette*. Two small works and a large painting on canvas depict night scenes, including the moon, city skylines, a park, reflections in a pond or in the ocean. (Ill. 16) Haystacks in the fields and stately poplars along a river bed were also painted. (Ill. 17)

Surely, the view of the river Seine, in Paris, and a tree-lined boulevard on the opposite bank, was stimulating, perhaps even romantic for this art student from America. There, on the wall, along the river, she sits in city apparel and cloche hat, with open paint box at her side. (Ill. 18) One cannot but see a resemblance, in spirit, between this scene and that of the one depicted by Claude Monet (1840-1926), entitled *The Floating Studio*.[20] On the reverse of Nicholson's painting, which must surely be a self-portrait of the artist, is a sketch of the Pavillon de Flore of the Louvre, at the Pont Royal, as seen from the left bank of the Seine. Next she went to Venice where she painted a significant number of beautiful works depicting houses, canals, bridges, water and a number of views of boats with earthen-colored sails, massed or singly, plying the lagoon. (Ills. 3 and 19)

When one studies the early paintings of L. M. Nicholson, it is easy to see the influence not only of a strong academic training, but also of her attempts to use her brush in the manner of established painters. This is true of subject matter as well as of style. Claude Monet appears to have been a favorite. Five examples can be cited to demonstrate this point. The two famous series of *Poplars* and of *Haystacks,* begun by Monet in 1880-1881, were surely known to Nicholson. Haystacks are the subject of at least two of Nicholson's works during her stay in Northern France. (Cat. Nos. 48 and 49) This motif was the subject of paintings by other Impressionists as well, and Nicholson tried her hand at fractured colors, loose brush strokes, and sketchy rather than precise outlines — at various times of the day, out of doors. Somewhat more somber are the country scenes along the river, with the ubiquitous poplars. (Ill. 17 and Cat. Nos. 53 and 58) The *Four Poplars* by Monet (1891) is a good example for comparison with one of Nicholson's delightful landscapes of this subject which also depicts haystacks. (Ill. 17)

As a student, she painted reflections in the water or nocturnes near Belvedere or Tiburon, California. (Ills. 11 and 12) At Etaples, she practiced city skylines at dusk, with a moon in the sky and reflections of light in a pond. (Ill. 16 and Cat. Nos. 40 and 41) In both instances she recalls the work of Whistler, with special emphasis now on his nocturnes. A strong stylistic resemblance is to be seen between these

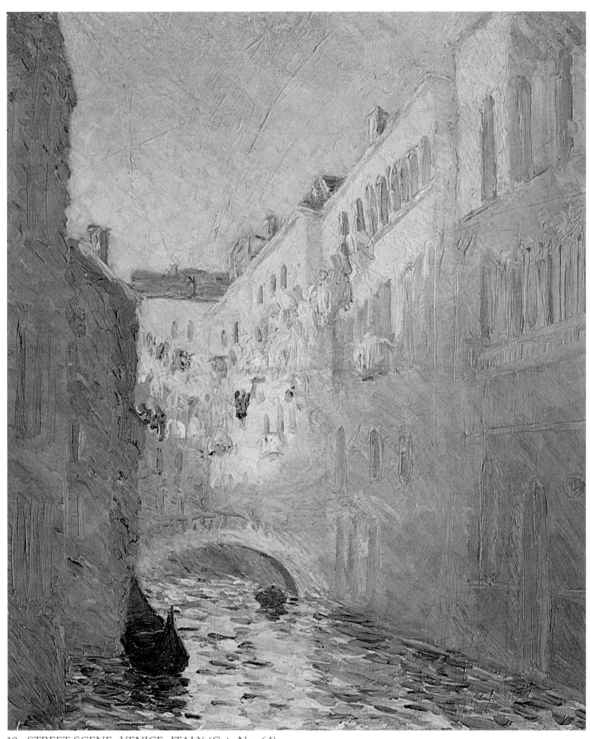

19. STREET SCENE, VENICE, ITALY (Cat. No. 64)

three works and Whistler's *Cremorne Lights* or the horizons of *Nocturne in Blue and Gold* and *Nocturne in Black and Gold.* These are, in a certain sense and mood, reminiscent also of Monet's extraordinary and epochal *Impression, Sunrise* (1872), from which the name of this artistic movement was derived — a work that also reflects light rays on water. Another model which occupied Nicholson's attention was that of sailing vessels at Venice. (Ills. 3 and 19) Many European, as well as American artists, most notably Thomas Moran (1837-1926), had been captivated by these graceful boats and their reflections in the water — all under bright Mediterranean sunshine *en plein air.*[21] To be mentioned, also, are a few attempts at the technique of pointillism, somewhat in the manner of Georges Seurat (1859-1891); mostly these resemble the style of her contemporary the Belgian painter, Theo van Rysselberghe (1862-1926) — especially one entitled *Perkiredec Point.*[22] (Ill. 17 and Cat. No. 58) Several works of this nature were painted in Pacific Grove. (See Ill. 56 and Cat. Nos. 234 and 235)

ARTIST IN PACIFIC GROVE: 1923-1933

Having traveled to Europe and back while she resided in Japan between 1911 and 1915, she probably left Europe this time, again by steamer, for the United States via the Orient, perhaps in May of 1922. A postal card depicting a waterway with small vessels in Shanghai, dated June 6, 1922, is postmarked U.S. Postal Service, Shanghai, China and was sent by her to relatives in Watsonville.[16] One might speculate also that she visited Japan en route home.

Miss Nicholson's father died in 1914 when she was in Japan and her mother in February 1921 prior to Nicholson's trip to Europe. The ranch in Aromas was divided by her brother Murdoch Nicholson among his five sisters, a brother and himself. For some time thereafter Miss Nicholson strove to have her share developed into a public park, but this very strong wish did not materialize and she sold her portion. Years later, another portion of the Nicholson ranch was incorporated into Royal Oaks Park situated southwest of the present Nicholson ranch in Monterey County.[1]

Neither the exact date of her move to Pacific Grove, nor her first address there, are known at this time. However, it appears to have been in 1923 or early in 1924. A letter written by her, but apparently neither completed nor mailed, is dated January 20, 1924 and bears the sender's address of "R.F.D. 4, Box 71, Watsonville, Cal." which was presumably that of the family ranch.[23] The address given in her handwriting on the reverse of many of her paintings is 667 Lighthouse Avenue. The first entry in one of two studio Guest Books was made on July 12, 1924.[24] Curiously, according to the Guest Book, on May 1, 1925, a Mrs. O. P. Thompson, from Atwater, Ohio, appeared to be residing also at 667 Lighthouse Avenue. Perhaps the explanation is that Miss Nicholson occupied one-half of the residence or duplex at that corner location. At this writing, the house has been moved to a

new location and a new building occupies the site. (Ill. 57)

In 1925, there are four entries in the Guest Book by Mr. Paul De Wolf of 891 Senix, Pacific Grove (October 3, 17, 23, and 28). Miss Nicholson married De Wolf in a civil ceremony at Salinas, California, on January 6, 1926.[25] Mr. De Wolf was a builder by profession; he was forty-two years old and this was his second marriage. Miss Nicholson listed her occupation as artist. Her age was listed as being thirty-three, instead of forty-one, as it really was. We know little about this marriage except that it was a union of short duration. Where the couple resided is not known either. In February of 1926, the then Mrs. Lillie Nicholson De Wolf received a parcel from San Francisco addressed to 663 (?) Lighthouse Avenue; also, a letter requested by her from the San Francisco Institute of Art was sent to her as Mrs. Lillian Nicholson De Wolf.[26] However, on June 9, 1926, there was a legal agreement made between the couple, indicating a prescribed monthly alimony for her in return for mutual relinquishing of claims to each other's property.[27] The couple then was living separately. Whether a divorce ensued is not known, but Lillie used her maiden name thereafter; whether any alimony was paid is not known either.

Miss Nicholson's fascination with water, the coast and boats, so prominent in her San Francisco and European works, would serve her well on the Monterey Peninsula. It was once said of Piazzoni, her favorite teacher during art school days in San Francisco , that he "paints nature, not cities. There are rare instances where we find

20. FOUR CHILDREN PLAYING
AT BEACH (Cat. No. 274)

 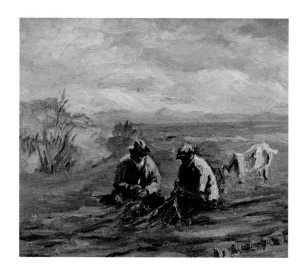

human beings or animals in his pictures, but they are just suggestions, just accessories, to a great scheme."[11f] This concept may have guided her when she painted about the Bay of San Francisco, as a student, but a number of the works created during her European sojourn, including one which must include her person, and most of the paintings executed as a mature artist in Pacific Grove, are precisely the opposite. (Ill. 20) Here, her major artistic preoccupation was with human subjects, mostly men at work; occasionally children playing and sometimes animals. (Ills. 21 and 22) Portraits, too, were numerous.[28] They are often full-face studies of rugged working men, oddly akin to the Ash Can School of honesty where every wrinkle shows, usually executed out of doors in the bright California sunshine. (See Ills. 43 and 44) Some portraits bear landmarks clearly locating them on the Wharf in Monterey. Nevertheless, Nicholson continued to paint many views of the dunes, the shoreline, trees, gardens, some buildings, an occasional ship ashore and other scenes around Monterey Bay. (Ills. 23, 24 and 25) She often employed palette knife instead of brush.

It is interesting how this artist, who painted much on cardboards twelve by sixteen inches, often utilized both surfaces on which to paint. After the pigment was dry, many of the cardboards were then "sliced" and the cut side covered with brown paper. This practice, no doubt, was an economical one "because canvas was so expensive."[29a] It is also related apparently to her habit of carrying her paint box with her and either executing the paintings with the board propped on it or on an old easel, and then transporting the finished product back to her studio. (Ill. 18) The box could accommodate several paintings in a grooved compartment within the lid and cardboards could be readily stashed, with paintings on both sides. At times she would paint on smaller pieces of canvas which were pinned up, it seems, onto

21. (left) SPIDER WEB NET
(Cat. No. 85)
22. (right) WORKING MEN AND GRAZING COW (Cat. No. 185)

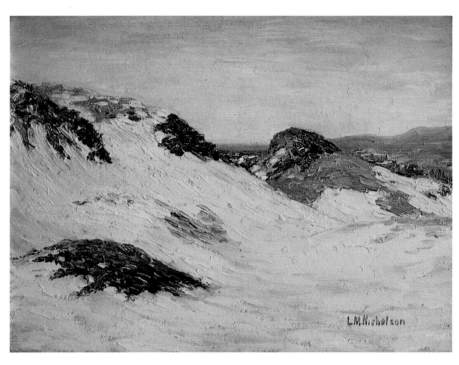

23. PINK SAND DUNES (Cat. No. 160)

cardboards and could be handled in the same fashion as the boards. The pin holes left by thumb-tacks are noticeable on some of the larger works. Only a few paintings exist which are larger than twelve by sixteen inches, and these are on stretched canvas approximately sixteen by twenty inches; the four largest known works are all in oil on canvas, approximately eighteen by twenty-four inches in size. These are: *Fishing Boats After the Shower, Etaples* (Cat. No. 46); *Etaples at Night; Waterfront* (Ill. 16); *Street Scene, Venice, Italy* (Ill. 19) and *Fallen Cypress at Blue Inlet, Monterey Coast.* (Ill. 26) To our knowledge, she never varnished her paintings or intended them to be varnished.[30]

In some instances, it is clear that school days' works depicting Bay Area locations are back-to-back with European scenes and at least three executed in Europe, one on wooden panel, two on cardboard are backed by coastal scenes or a lake shore, typical of California. (Ill. 27; see also Cat. Nos. 51 and 330)

There are two interesting paintings of children which were apparently done shortly after her return from Europe. (Ills. 28 and 29) Both are painted in shades of brown, purple, white and sand color, in a modified Impressionist technique. One depicts two children and is entitled *Boys – California,* suggesting a stay elsewhere had just preceded the painting of this work. The other depicts a young girl under an umbrella in a rainy windstorm, standing at the water's edge.

In connection with the art of painting, it was recorded first in 1900, and then later in 1937, and again in 1976 that "while all the artists

24. FLOWERS AND TREES IN GARDEN SETTING
(Cat. No. 308)

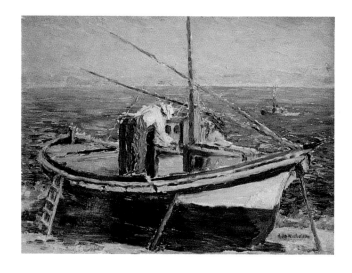

25. STRANDED FOR REPAIRS (Cat. No. 92)

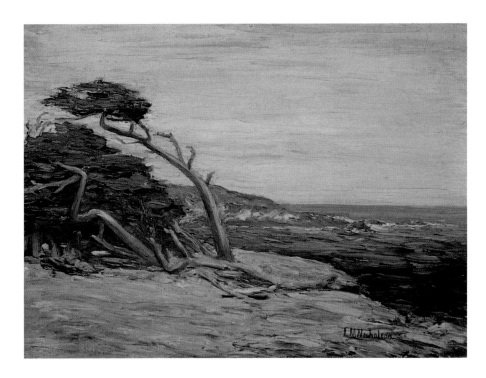

26. FALLEN CYPRESS AT BLUE INLET
 (Cat. No. 196)

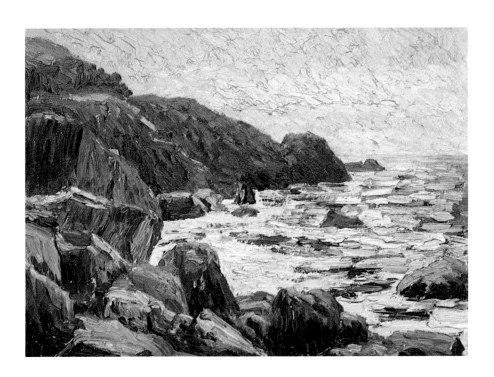

27. LANDS END, SAN FRANCISCO
 (Cat. No. 33)

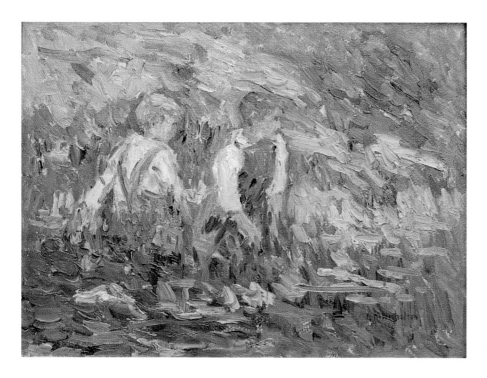

28. TWO BOYS — CALIFORNIA
(Cat. No. 86)

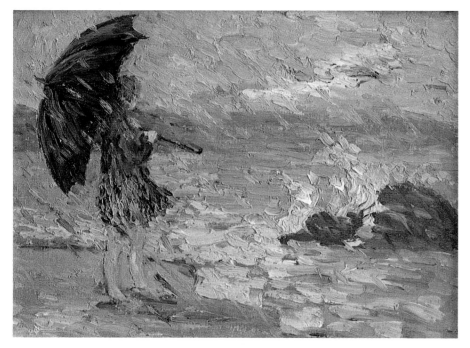

29. GIRL WITH UMBRELLA AND ROCKY
SHORE (Cat. No. 87)

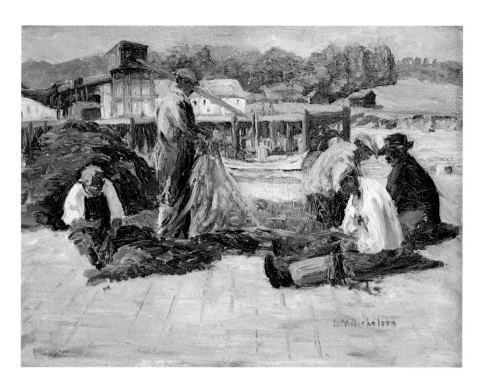

30. MENDING NETS AT FISHERMAN'S
 WHARF (Cat. No. 121)

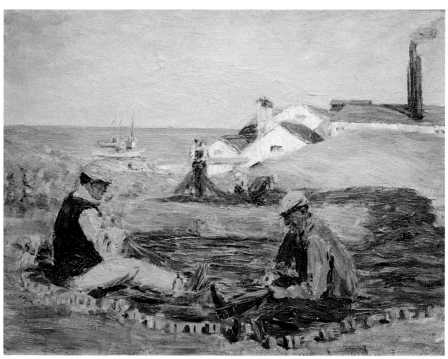

31. MENDING NETS BEHIND CANNERY
 ROW (Cat. No. 100)

recognized the necessity for general work, there is a decided leaning toward specialization and it is emphasized more in Monterey than anywhere else."[29b] How much of the works of other painters on the Peninsula were known to L. M. Nicholson is not clear to us. It is safe to say, no doubt, that she had known Pacific Grove, near Monterey, as a child, having been born relatively near there, north along the coast at Watsonville. It was climatically and topographically suited to her painterly needs in that she could paint outdoors all year and that she was near the water for which she had long since formed an attachment. Pacific Grove was also an artists' colony and well-established as such, along with Monterey and Carmel. Yet it has been repeatedly stated by those who knew Nicholson that she was quite self-sufficient in her social needs. Indeed, she appears to have been a "loner"; what it really amounts to is that she did not "run with the pack" of her artist-peers. Additionally, Miss Nicholson abstained from alcoholic beverages. All of these attributes left her out of the mainstream of social and professional activities which often accompany and further an artist's career. In this regard, Miss Nicholson may have been at a disadvantage in terms of public relations. On the other hand, that she was a woman, which has often led to discrimination in professional careers, cannot have been, in itself, a disadvantage to Miss Nicholson. A veritable legion of women of all ages and social standing have long-since come to the Monterey area, either as trained artists, some of professional standing, or in order to study there, under a considerable number of accomplished artist-teachers. Perhaps it was her innate shyness which led her to "go it alone."

A final and most significant factor contributing to the obscurity of Miss Nicholson's *oeuvre* was the curious lack of esteem which she demonstrated for her own work. It has even been said that Miss Nicholson eventually grew to dislike her own work. In any event, she ceased to paint when she was about fifty years old; in later years, after she had not painted for ten years or so, she attempted to burn the residue of her work which had been stored at the family ranch near Watsonville.[1,4,30] Family members, however, intervened, and many of the works were saved from destruction.

Of the paintings that do survive, and particularly the works dealing with the activities of fishermen, most reflect a sense of calm, harmony, and at times, good humor. Whether the action involves mending nets, her most popular subject matter, or unloading a catch of fish at the docks, steaming crabs, plucking geese, playing cards — a certain distinctive trait of quietude prevails. (Ills. 30, 31, 32 and 33) Perhaps the calmest picture known of hers is that of a man sitting on a park bench, overlooking the peaceful Bay of Monterey, near the Custom House and looking towards the mountains on the horizon. (Ill. 34)

Among the many artists active near Pacific Grove during the years 1923-1933, none concentrated to the extent that she did on the activities of the fishing industry with the exception of the legendary

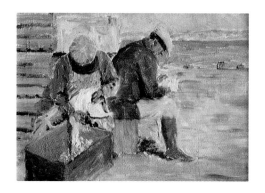

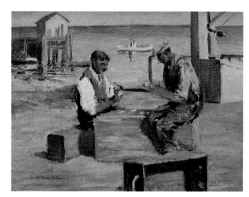

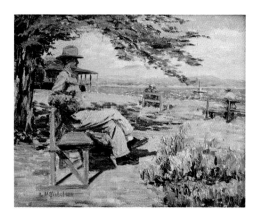

32. (top) PLUCKING GEESE (Cat. No. 319)

33. (middle) TIME OUT FOR CARDS (Cat. No. 79)

34. (bottom) MAN SEATED AT BAY PARK NEAR CUSTOM HOUSE (Cat. No. 108)

painter of fishermen, Armin Hansen, two years her junior; he came to Monterey in 1913. If her fishermen at work at first remind one of the paintings of Armin Hansen, hers quickly reveal a sharp contrast to his. There is no drudgery, no bustling, no rain-drenched, storm-blown, hard-working effort to eke out a livelihood from the sea. The works of Hansen, like many other artists in that period, are full of social commentary. The paintings of Nicholson, on the other hand, simply show persons at work — work perhaps of a tedious or boring nature, but nevertheless done by individuals working at their choice, and doing so contentedly. (Ills. 35 and 36)

No study by Nicholson in this category lacks a story, composition or color, especially the latter; all are spontaneous and yet peaceful. Percy Gray (1869-1952), the famous California water colorist, lived in Monterey during precisely the same time that Nicholson had a studio in adjacent Pacific Grove: 1923-1938. The calm yet strong expression in his numerous paintings, mostly in water color, ranging from coastal scenes, sand dunes, to inland pastorales, reflect Gray's response to the beauties of the Monterey Peninsula. Had he painted human beings then, as he had early in his career, they too would have been at ease in their environment.

Sand dunes, their flora, the blue-green waters of the Pacific Ocean appearing between mounds of sand covered with blossoms, an occasional glimpse of the fog, were done by innumerable artists. Among these were Franz A. Bischoff (1864-1929), Henry Joseph Breuer (1860-1932), Percy Gray (1869-1952), Clark Hobart (1880-1948), Christian or Chris Jörgensen (1860-1935), Bertha Stringer Lee (1873-1937), Lucia K. (1870-1955) and Arthur F. Mathews (1860-1945), Mary De Neale Morgan (1868-1948), Frank M. Pebbles, Sr. (1839-1928), Theodore Wores (1859-1939), and many others. Nicholson likewise painted coastal views and glimpses of sand dunes. (Ills. 37 and 38)

Bertha Stringer Lee, of San Francisco, was a frequent visitor at the Nicholson studio[24] — one of the few contemporary artists who signed the small studio register. It is obvious that Nicholson and Lee had much in common, artistically speaking, particularly as regards views of the coast and the sea. The other well-known artist whom Nicholson apparently befriended was Jeanette Maxfield Lewis. Mrs. Lewis visited the studio on occasion. Twice Mrs. Lewis sent to Nicholson in Oakland presents of etchings, after Nicholson had moved there following the closing of her studio in Pacific Grove.[31] The first came from Fresno, in 1950. It was a small work entitled *Rain,* for which she had received recognition and awards.[32] It was dated 1950 and dedicated to "Lillie Nicholson." The second, sent from Pebble Beach in 1961, was the "ninth final version" of a 1954 etching entitled *Danish Fish Market,* appropriately, depicting fisher-folk at work.

A contemporary of Miss Nicholson's in Pacific Grove was the painter, William Adam, the English-born artist who came to California in 1894 and lived in Monterey and Pacific Grove. Adam concen-

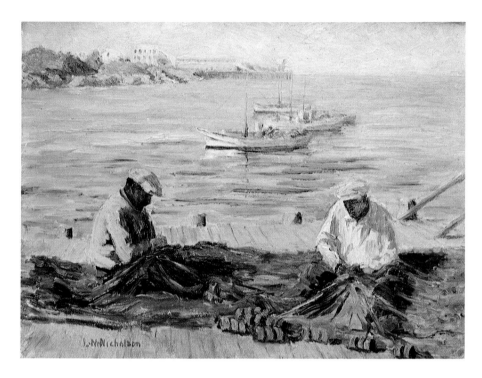

35. TWO MEN SEATED ON PIER;
 CANNERY ROW BEYOND
 (Cat. No. 115)

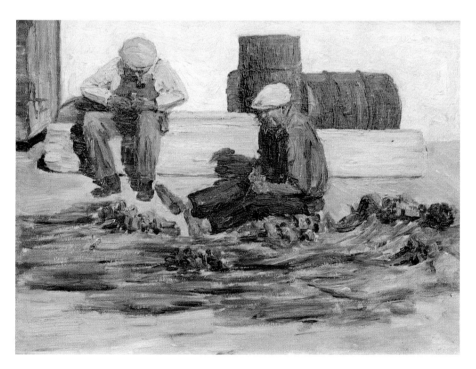

36. MENDING NETS NEAR DRUMS
 (Cat. No. 145)

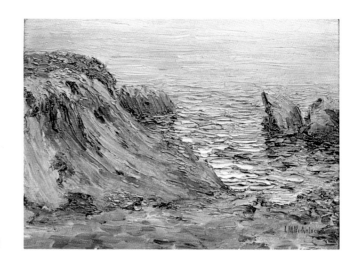

37. COLORFUL PRECIPICE AND
 ROCKY COAST (Cat. No. 125)

38. PURPLE CLIFFS (Cat. No. 178)

trated on garden scenes and cottages; but Adam also painted dunes and the ocean. Illustrated post cards of these coastal views by him and other artists were collected by Miss Nicholson and saved, together with family photographs.

THE OAKLAND SKETCH BOOK: 1934-1937

The 1933 edition of *Polk's Monterey Peninsula Directory* lists L. M. Nicholson, Artist, as residing at 667 Lighthouse Avenue, Pacific Grove. Yet, a break in the chronicle of L. M. Nicholson's life was a residency in Oakland, between 1933 or 1934 and 1937 and 1938. It is neither known why she moved to Oakland nor exactly where she lived during this period. Previously, while teaching there in 1921, she had resided at the Delmar Inn, 15th and Jackson Streets.[33] Later she was known to have lived at the Sutter Hotel, 14th and Jefferson,[1] but her residence during this interval in the 1930s is unknown.

For several reasons, however, it is likely that she resided in downtown Oakland. There exists a thick folder of pencil drawings executed during this period which indicate some of Miss Nicholson's activities then, and they all point to a residency in the inner city. Most of the sheets and drawings are dated and located; the earliest is marked May 1, 1934. The collection consists almost exclusively of small studies of men and women observed at five or six locations — the library, the stock market, the court house, Lake Merritt, Chabaud (sic) Park and Glad Tidings Mission on Tenth Street. Many faces occupy one page. (Ills. 39, 40, 41 and 42) There are studies of court-room scenes, including faces and figures of spectators, judges, attorneys, witnesses, defendants, as well as persons seated at the table reading or simply resting on park benches. Interspersed throughout is the familiar theme of water; studies at Lake Merritt include ducks in various poses, children fishing, and a park keeper feeding the fowl. Here and there, among portrait studies, appears a sketch of a lonely sailboat, a single page with two studies of men on ladders, painting a wall; a small study of a "city canyon" or narrow street as sketched from several stories above, and so on.

Whether Nicholson painted anything in color during these years is unknown. There are strangely mixed written inserts in the sketches; some refer to question and answer sessions in the court-room, vocabulary exercises in Japanese and French, as well as a page devoted to "Communist Banner Slogans (Oakland, May 1, 1934)" which attracted her attention during a demonstration. Of interest to her, and worth recording among these, were such slogans as

— From the friends of the Soviet Union for Higher Wages to meet rising . . .

— Smash Capitalism, Build Socialism

— Berkeley Working Women's Club, We want Schools — Not Battleships

— No Cuts in Old Age Pensions

39-42. Pages from the Oakland Sketch Book. Pencil

But she also found the time to sketch on the "nickel ferry" (presumably to San Francisco) as well as do a group of Masons with plumed hats at the *Laying of the Cornerstone for the (New) Court House, Alameda County, Oakland, October 12, 1935.* The last date written on a sketch was July 22, 1937.

CLOSING THE STUDIO: 1938

Possibly in early 1938, Miss Nicholson returned to Pacific Grove for what appears to have been her last short engagement as a professional artist. Her studio Guest Book for that time records an "Open House, 1938, October 1st to 2nd." Among other visitors was the artist, Louise

 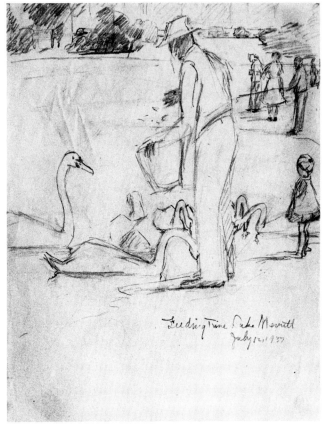

M. Carpenter, (1835-1963) formerly of Berkeley, and then residing at Pebble Beach, who visited on October 20; the last entry in the book is dated December 16, 1938. Perhaps her activities as a painter continued for a while thereafter, but there is no record of this. We must assume that L. M. Nicholson's art career had effectively ended in 1933, with her departure for Oakland and that her return to Pacific Grove was for the purpose of closing her studio and preparing to end her residency there.

However, the few extant portraits of men in oil on canvas may have been executed by Nicholson in Monterey, after her intermediate stay in Oakland.[28] (Ills. 43 and 44)

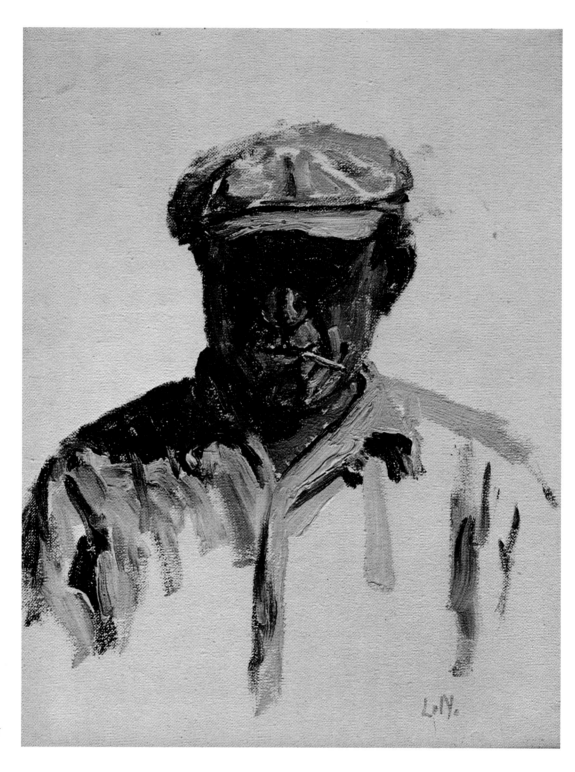

43. PORTRAIT OF MAN
 (Cat. No. 314)

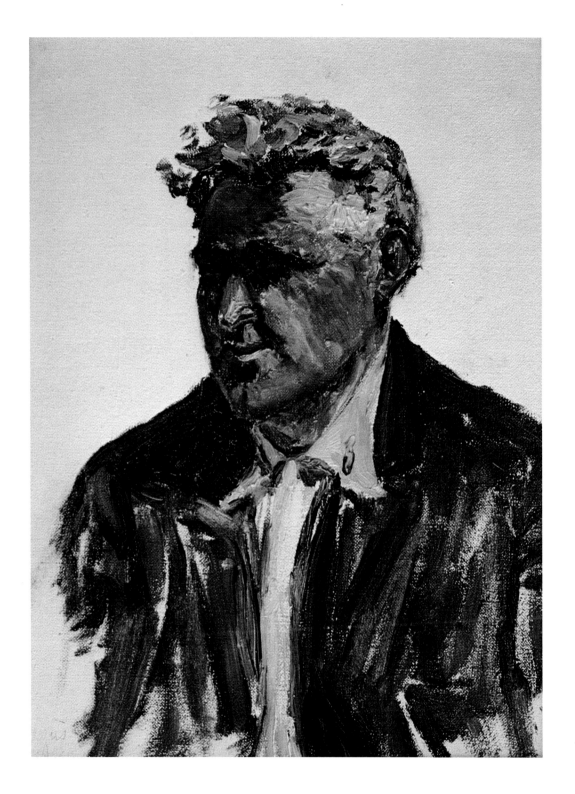

44. PORTRAIT OF WILGUS
(Cat. No. 315)

ARTISTIC CREATIVITY

Curiously, while many of the sketches in the Oakland Sketch Book were meticulously located and dated, only four of Nicholson's known paintings are dated. Few are given locations. One of these, marked 1902, probably executed while in school near Aromas, is a botanical sketch in pen and ink. The second, dated 1920, depicts red factory buildings or warehouses along a shoreline — possibly in Marin County, at the foot of Mt. Tamalpais. (Ill. 8) The third, mentioned previously, is labeled "1923" and depicts *Fishing Boats After the Shower*, at Etaples, France, and was scheduled for the "California Industries Exhibition" as an "Artist's Exhibit." (Cat. No. 46) The fourth painting was probably done at the end of her European tour (1921-1922), and was mentioned in the Introduction. It bears three labels on the reverse and is entitled, by her, *Fishing Boats – Venice*. (Ill. 3) The first label gives her name and address and states that "this painting is not for sale." It is also faintly inscribed: "Shown at Carmel Xmas 1927, Santa Cruz and Arizona 1927." Another label was affixed for an Art Exhibition, Arizona State Fair, and a third for the First Exhibition Santa Cruz, California Art League, February 1-15, 1928.[34] There is no record of the exhibition at Santa Cruz, but interestingly a companion article to the newspaper critique on December 27 mentioned in the Introduction states that several Carmel artists had exhibited at the "recent" Arizona State Fair, although no date was given. Thus, it would seem safe to say that Miss Nicholson had made attempts to exhibit her work. In this regard also some paintings bear serial numbers and, in one instance, one reads the comment "her number," next to one of two numbers, thus indicating that the work was at least considered for an exhibition. We are told, however, that on one occasion, in Carmel, when she was scheduled to discuss a forthcoming exhibition, she vacillated at the door of the gallery and did not keep her engagement.[30] One cannot but wonder whether any of her Monterey fishermen paintings were ever exhibited, and why she chose to exhibit a Venetian scene done in 1922 at least twice and probably three times during 1927-28. Perhaps only a few of her contemporaries had ever been to Venice.

In spite of the lack of dates on Nicholson's work, chronology of her work is possible with reasonable accuracy, based on considerations of the type of support used and particularly of style. Six general periods may be recognized:

Carneros School, near Aromas, California: drawings in ink or pencil on paper, around 1902

Watsonville: water colors on paper, 1910-1911

San Francisco Institute of Art: pencil and charcoal sketches of figures on paper, landscape paintings in oil on cardboard, 1916-1921

Europe: oil paintings of landscapes, seascapes, some for the first time with figures, some on wooden artist panels with French labels imprinted on the reverse, 1921-1922

Pacific Grove, California: oil paintings in brush and palette knife of marines, fishermen, dunes, gardens, seascapes, and portraits in open air, mostly on cardboard, twelve by sixteen or sixteen by twelve, 1923-1933[28]

Oakland Sketch Book: pencil exclusively on eight and one-half by eleven paper, mainly portrait studies, 1934-1937

As noted previously, many paintings were destroyed by Nicholson herself. However, she must have sold some during her studio days in Pacific Grove, and at least one is said to have been sold at Gump's, a fine arts store in San Francisco in the late 1920s.[1] There are presently three hundred and twenty-one known oil paintings by L. M. Nicholson. Of these, sixty-four remain which are painted back-to-back on twenty-nine boards and three canvases. There are four small drawings on paper, three in pencil, one in ink, the latter dated 1902, and six known water color paintings on paper. There are fourteen large pages of pencil or charcoal drawings on ten sheets of paper. The Oakland Sketch Book consists of one hundred and fifteen sheets, with drawings on both sides. There are presumably known thirteen to fourteen paintings not available for recording. One collection of paintings recorded here could not be removed from the walls and may consist of several "double" paintings. All extant works are listed in the Catalog of Known Works (p. 69) and the Supplement; one painting on the reverse of another is covered up by paper. One small oil painting was lost in transport.

Possibly her first oil painting was that depicting a coastal scene which resembles a later one of Carmel Bay. (Cat. No. 179) It was done while a student at the Art Institute. (Ill. 45) This work was framed in San Jose, near Santa Clara, where she lived during the school year and worked as a teacher. Her last is thought to be a view of blue waters through Monterey pine trees. (Ill. 46) This painting was found inside one of her paint boxes.

Her legacy, that is to say her unique and creative achievement in art, is the series of close-up views of the shores of Monterey Bay with the numerous intimate scenes depicting the fishermen of a bygone era. (Ills. 47, 48 and 49)

WARTIME AIRCRAFT MECHANIC: OAKLAND-ALAMEDA 1939 (?) - 1945

World War II began with the attack on Poland by Germany on September 1, 1939. Germany was joined in the conflict by Italy and Japan, united as the Axis powers. They declared war on Russia in June, and Japan attacked the United States on December 7, 1941. Germany surrendered on May 8, and Japan, on September 2, 1945.

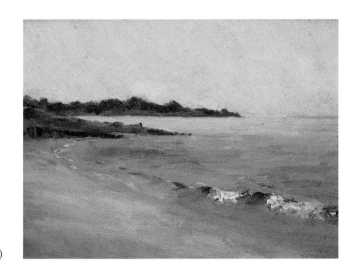

45. COASTAL SCENE (Cat. No. 21)

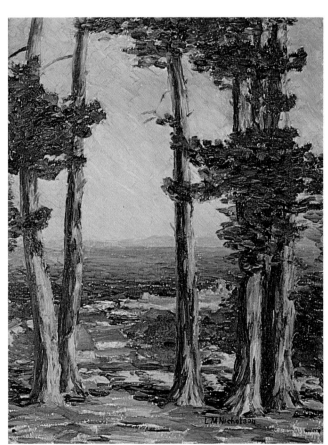

46. CYPRESS AND VIEW OF BAY
 (Cat. No. 84)

In 1943, Lillie May Nicholson, residing again in Oakland, California, completed two hundred and twenty-four hours of work in sheet metal school (July 28 to August 30) and three hundred and sixty-eight hours of training as an Aircraft Engine Mechanic at the Alameda Board of Education Motor School, Alameda, California, on November 23.[35] Miss Nicholson was then fifty-nine years old, and presumably already at work at the U.S. Naval Air Station in Alameda. Further training made her competent in Aircraft Overhaul and Inspection and qualified her as an Aircraft Engine Inspector. During February, 1945, and as a Mechanic's Helper at maximum wage, she submitted a suggestion accompanied with a mechanical drawing for a part's improvement, for which she received a prize and Certificate of Award, and was congratulated by the Commodore on May 2, 1945. A group photograph on this occasion depicts Miss Nicholson in company with fellow workers.[6] Thereafter, on September 2, 1945, she received a certificate: In Recognition of Service from the United States Navy.

It is not certain where Nicholson resided during this time but she continued to receive her correspondence at the Oakland Main Post Office and, on one occasion, at the Securities Office of the Bank of America at Broadway and 12th Street. This latter was an additional Commendation in 1946 for her Contribution to the War Effort as a Mechanic.

LATER YEARS: 1946-1964

Having terminated her third career, that of an aircraft mechanic, L. M. Nicholson retired at Oakland, California. She is said to have led a very frugal, but contented existence. Little or nothing is recorded of her activities during her last eighteen years, except for occasional visits to the ranch near Watsonville for family reunions. As mentioned, she apparently corresponded with acquaintances like Jeanette Maxfield Lewis and was known to have been a close friend of the American song writer, Carrie Jacobs Bond, who died in 1946.[36]

Her health, strong in younger years, began to fail with progressive loss of eyesight and circulatory infirmities. Following a hospitalization for a short period, she died several months later in her room at the Sutter Hotel at 14th and Jefferson Streets in Oakland on November 28, 1964. She was eighty years old.

A fellow resident and later employee of the hotel, who knew Miss Nicholson for many years, remembers her as "a very fine woman, who never bothered anyone, kept mostly to herself, but always had a pleasant well-spoken word for you, and never failed to say thank you."[37] This seems a fit epitaph for a sensible, self-possessed woman, who had the gift of creating an unusually individual body of work during her creative years.

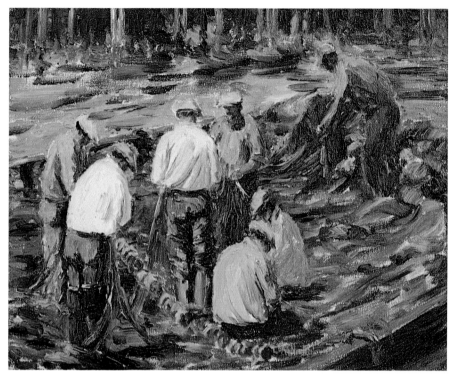

47. MENDING NETS ON BOARD
(Cat. No. 181)

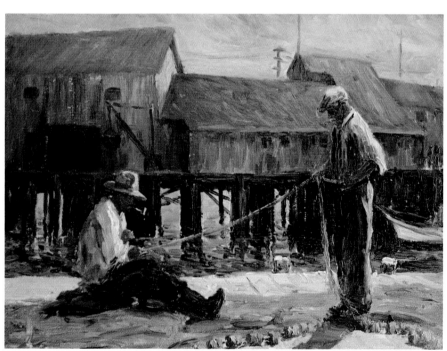

48. MONTEREY WHARF BUILDINGS
(WEST SIDE) (Cat. No. 127)

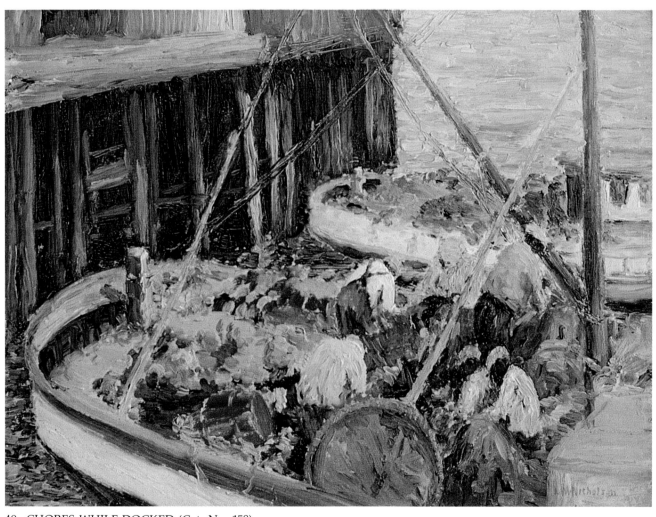

49. CHORES WHILE DOCKED (Cat. No. 158)

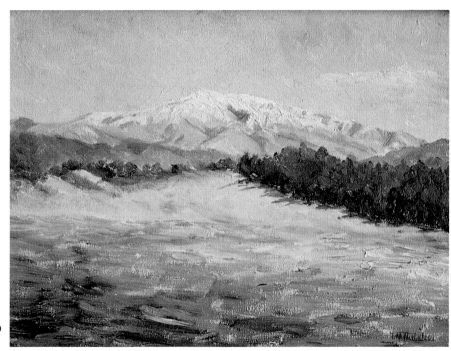

50. SANDY BEACH AND MT. TORO
(Cat. No. 144)

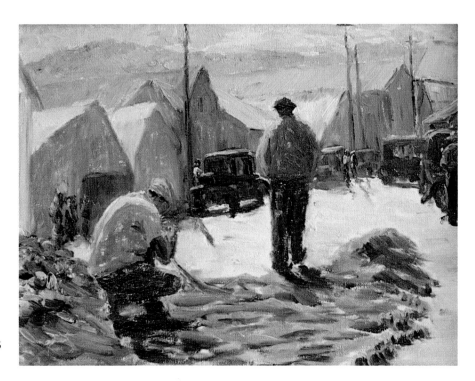

51. ACTIVITIES ON FISHERMAN'S
WHARF (Cat. No. 91)

Envoi

The initial excitement which accompanied the discovery of Nicholson's paintings in two old wooden trunks, seemingly destined for oblivion, persists through the realization that Nicholson has left behind not only a considerable body of art, but of history as well. Curiosity about the locale of many of the scenes which she painted was most recently satisfied after comparing them with contemporary photographs taken in the 1920s and early 1930s. Of particular value for comparison are the many scenes on or near the wharfs in Monterey.[38]

Although artistic liberties are apparent in composition and coloration, faithfulness in representation of buildings and tools of the fishing trade is remarkable. The accuracy in her depiction of clothing and costumes of the day or of automobiles and trucks of period design, not only assists in the dating of Nicholson's work, but strengthens her role as a keen observer and recorder of reality.[39] One is reminded of the work of Edward Potthast (1857-1927), as in his many beach scenes and the unique *Tin Lizzie in the Lamplight*.[40] Adherence to nature is clearly visible as well in many of her landscapes and coastal scenes, the locations along the water or of nearby mountain ranges being clearly discernible today. (Ills. 50, 51 and 52) It is apparent that the view of Mt. Toro east of Monterey Bay was as spectacular then as it is today and Nicholson depicted it as a backdrop on the horizon of a number of her paintings.

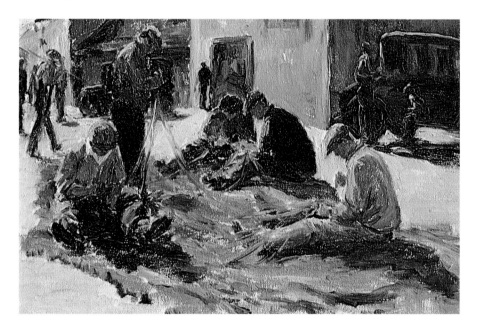

52. MENDING NETS, WEST SIDE
FISHERMAN'S WHARF (Cat. No. 68)

Witch cypress, past monarch, forlorn
Twisted and snarled by wind and storm
and bowed by nature's sympathetic tones,
Our rugged coast you still adorn.

(Final version of a verse discovered on the
inside cover of her studio Guest Book)

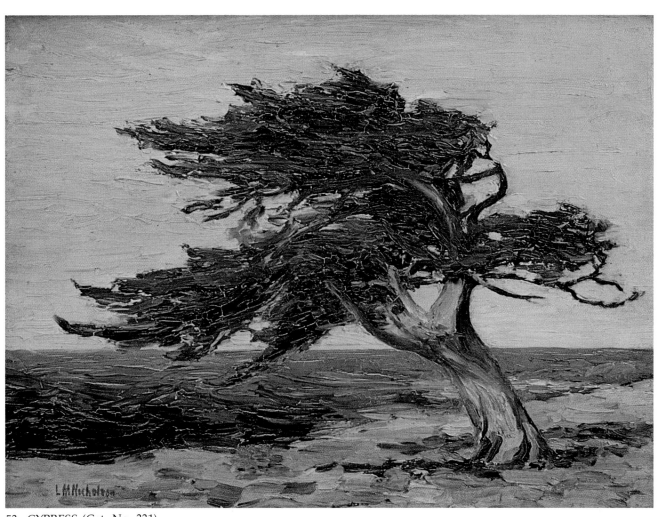

53. CYPRESS (Cat. No. 331)

Notes

1. Most of the information regarding dates in the life of Lillie M. Nicholson were graciously provided by her sister, Emma Hazel Nicholson of Watsonville, California. A death certificate for L. M. Nicholson, also bearing vital statistics, was accepted for registration at the Alameda County Court House on December 1, 1964.

2. Information, courtesy of Mr. Sanford Colburn, Assistant Assessor, County of Monterey, Salinas, California.

3. Information courtesy of a friend of the family and relative by marriage, Mrs. Nell Kortright Evey, San Francisco, California.

4. Diploma of Graduation, dated June 21, 1907.

5. *Salinas Daily Index* (Salinas City, Monterey County, California), Tuesday evening, January 14 and Wednesday evening, February 12, 1908.

6. During the preparation of this manuscript, in October of 1979 notes and photographs were taken from the author's car in Oakland, California. Among those items was a photograph of Miss Nicholson and other guests aboard the battleship *Wisconsin,* in the harbor at Honolulu, taken in July of 1909.

7. An undated clipping from an unknown newspaper exists. An item on the reverse, by the Vokusai Reuter News Service, is datelined Copenhagen, June 14, and states that "the King and Queen of Italy are expected to visit Copenhagen August 19 and afterwards visit Brussels."

8. During these years this school was known both as the San Francisco Institute of Art and the California School of Fine Art. Presently, and since 1961, its name is the San Francisco Art Institute. Information courtesy Mr. Harry Mulford, Archivist.

9. Christian Brinton "The San Diego and San Francisco Expositions," *Fine Arts Journal,* March 1915, pp. 116-126.

10. T. H. Watkins, *California: An Illustrated History,* quoted in Jan Butterfield, "Made in California," *American Art Review*, July, 1977, v. 4, no. 1, p. 122.

11. Gene Hailey (ed.), *California Art Research*, San Francisco, California Art Research Project, 1936-1937, Works Project Administration, twenty volumes (see vol. VII, Gottardo Piazzoni); a, p. 60; b, p. 34; c, p. 71: the first generation being presumably the one including Thomas Hill (1829-1908), William Keith (1839-1911), and other artists of the fourth quarter of the nineteenth century in California; d, p. 62; e, p. 66; f, p. 72.

12. Office of the Santa Clara County (California) Superintendent of Schools, courtesy of Ms. Judy Heath and Mr. James R. Sikora. Personnel Office, Oakland Unified School District, Oakland, California, courtesy of Mrs. Violet Soward.

13. J. A. M. Whistler (1834-1903). See: *Cremorne Lights* in: Sir William Orpen, *The Outline of Art,* New York, G. P. Putnam's Sons, 1924, vol. 2, facing p. 377; *Nocturne in Blue and Gold* (Old Battersea Bridge) in: Pierre Courthion, *Impressionism,* New York, H. N. Abrams, 1977, p. 69; *Nocturne in Black and Gold* (The Falling Rocket) in: James T. Flexner, *Nineteenth Century American Painters,* New York, G. P. Putnam's Sons, 1970, p. 152. The quotation under Ill. 16 is from Whistler's famous lecture known as the *Ten o'Clock.* The author owns a photo-

graph copied from one in the possession of Louis B. Siegriest, a member of *The Society of Six*. It depicts the Belvedere coast line from Selden C. Gile's porch. The scene is reminiscent of the ones depicted on both the Belvedere and Tiburon paintings. (Ills. 11 and 12) Of interest also is the fact that G. Piazzoni lived next-door to Gile in the same water front area, according to L. B. Siegriest, 1980.

14. As mentioned above (6), some photographic material has been lost, but one of these two copies was on loan at the Oakland Museum during that time and was thus saved. (Ill. 2). The original photograph was seven and three-fourths by five and three-fourths inches, mounted on paper, signed in the lower right and dated.

15. Therese Thau Heyman, *Celebrating a Collection: The Work of Dorothea Lange*, Oakland, The Oakland Museum, 1978, p. 97. Mrs. Heyman viewed the photograph of Nicholson in 1979 and commented on its unusual yellow-brown hue. The negative does not appear to be among those in the collection at the Oakland Museum. It is thought now, on the basis of this work, that Lange, then employed at Marsh's, a dry goods and photo-finishing store on lower Market Street, San Francisco, must have accepted some studio work on her own and that she was allowed to utilize the facilities of either the store or of someone else, before she opened her own studio in 1919.

16. Postal cards and letters in the possession of Mr. and Mrs. H. P. Henrichsen, Watsonville. Mrs. Henrichsen is the daughter of Sarah B. Wimmer, née Nicholson, who was a sister of the artist.

17. C. Brinton, J. B. Christopher and R. L. Wolff, *History of Civilization*, New York, Prentice-Hall, Inc., 1955, two volumes (vol. 2, p. 590).

18. Nancy D. W. Moure, *Directory of Art and Artists in Southern California Before 1930*, Los Angeles, Privately Printed, 1975.

19. See illustration of painting entitled: *Garden in Etaples* by F. H. Richardson in: *The Magazine Antiques*, June, 1980, vol. 117, p. 1186.

20. Claude Monet (1840-1926). See: Albert Skira, *The Taste of Our Times*, Cleveland, 1958, The World Publishing Company, Monograph Series: frontispiece; *The Floating Studio* (fragment) ca. 1874; pp. 83-85, *Poplars at Giverny*, 1888; *Poplars*, 1891; (Four) *Poplars*, 1891; p. 86, *Haystacks*, 1891; pp. 96-97, *The Ducal Palace, Venice*, 1908; *The Grand Canal, Venice*, 1908; (also relevant: *Impression, Sunrise*, p. 54).

21. Thomas Moran (1837-1926). See: T. S. Fern (ed.), *The Drawings and Water Colors of Thomas Moran*, exhibition catalogue, University of Notre Dame, Notre Dame, Indiana, 1976, p. 79, *Splendor of Venice*, 1889.

22. Georges Seurat (1859-1891), Theo van Rysselberghe (1862-1926). See: Francesco Abbate (ed.), *Impressionism: Its Forerunners and Influences*, New York, Octopus Books, 1972, p. 114, *Perkiredec Point*. (Ill. 56).

23. This six-page, unfinished letter was addressed to a Mrs. Long and constitutes a concise dissertation on Buddhism, Shintoism and religious beliefs in Japan of the period.

24. The two small Guest Books contain entries dating from July 12, 1924, to December 16, 1938. Among the entries are names of contemporary California artists such as

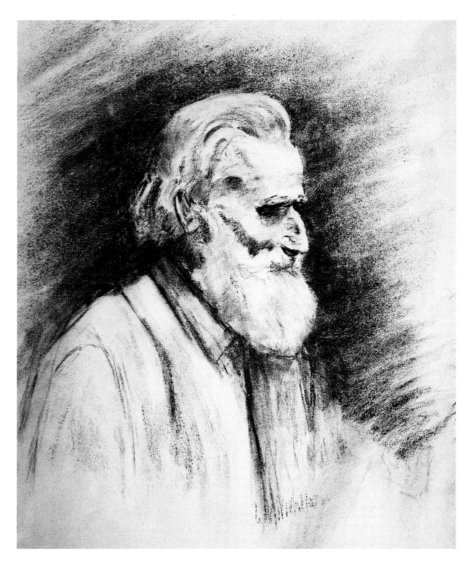

54. PORTRAIT OF OLD MAN,
SAN FRANCISCO INSITUTE OF ART
(Cat. No. 17)

Bertha Stringer Lee (1873-1937), Frank M. Pebbles, Sr., (1839-1928), Jeanette Maxfield Lewis and Louise M. Carpenter (1865-1963).

25. Standard Certificate of Marriage, dated January 6, 1926, State of California Department of Health Services, Office of the Registrar of Vital Statistics, Sacramento, California.

26. This letter, a copy of which is at the Institute, was signed by Lee F. Randolph (1880-1956), himself a painter and teacher, and the Director of the Institute of Art from 1917 to 1941. It is a resume of her curriculum at the Institute.

27. This Agreement was dated June 9, 1926. It was executed in Santa Cruz County and is recorded by the County of Monterey Recorder in Salinas, California.

28. In consideration of the numerous studies of men's faces and features appearing in the Oakland Sketch Book (see pp. 43-45), it is very likely that Nicholson

painted these small portraits in color on canvas upon her return to Pacific Grove, after her stay in Oakland lasting from 1934 to 1937.

29. Helen Spangenberg, *Yesterday's Artists on the Monterey Peninsula*, Monterey Peninsula Museum of Art, Monterey, 1976; a, p. 62; b, p. 25.

30. This, according to Mrs. Margaret Hawkins Houghton, of Hollister, California, a relative of Nicholson.

31. Curiously, Miss Nicholson apparently received all of her mail then at P.O. Box 644, Oakland 4, California, located in the old Oakland Main Office on 13th Street between Jackson and Alice Streets, although she lived for many years and to the end of her life at 14th and Jefferson Streets, ten city blocks away.

32. According to her grandson, Peter C. Lewis, Esq., of Pebble Beach, California, June, 1979.

33. In 1921, known also as The Del Mar Apartments; today the Jackson Residence Club, at 1448 Jackson Street.

34. Anonymous. See: *Artists and Writers and Such* in: *Carmel Pine Cone*, Friday, December 9, 1927, p. 4; also in: *Monterey Peninsula Herald*, December 16, 1927 (page not known). The Arizona State Fair Exhibition is mentioned under: *Among Artists*, on the same page as the *Pine Cone* critique. Interestingly, a contemporary of Nicholson's, the painter Rinaldo Cuneo (1877-1939), exhibited at the Santa Cruz Art League show in 1928 and won second prize for his painting *Winter on the Desert* (see volume XI, p. 99, in note number 11, above).

35. A Vocational Training Record Card exists issued by the Alameda Board of Education, Motor School, to Lillie Nicholson on November 24, 1943, as an Aircraft Engine Mechanic. On this card, Miss Nicholson wrote: "Just before entering motor school went to sheet metal school 224 hours July 28 to August 30, 1943 — no credit given on this for that time." The Vocational Training Division of the United States Naval Air Station, Alameda, California, issued her a certificate for completion of thirty-two hours in Aircraft Engine Overhaul and Inspection on December 27, 1944, and in February, 1945, for thirty-two hours in Aircraft Engine Inspection.

36. Information courtesy of her nephew, William (Bill) Nicholson, of Watsonville, California, 1979.

37. Information courtesy of Duncan Wallace MacMillan, Sutter Hotel, Oakland, California, who had known her as a resident and who discovered her body there on November 29, 1964.

38. Of good use in authenticating many of the locations depicted by L. M. Nicholson have been two publications: John and Regina Hicks, *Cannery Row: A Pictorial History*, Carmel, California, Creative Books, 1972, 1979, and particularly for locales on and near the wharfs in Monterey: Randall A. Reinstedt, *Where Have All the Sardines Gone*, Carmel, California, Ghost Town Publications, 1978. (Ills. 59, 60 and 61)

39. Among Nicholson's favorite books was one which she gave to her nephew, Bill Nicholson, in later years. It was about the painter and teacher William Morris Hunt (1824-1879), by an anonymous author; it is entitled: *W. M. Hunt's Talks about Art*, London, Macmillan and Co., Ltd., 1901. Several paragraphs believed to be marked by Nicholson include references to nature. One of these, on page 84, seemed appropriate to our story of L. M. Nicholson and is cited at the beginning of this work (p. 16).

40. Edward Henry Potthast, *Exhibition of Paintings, June to August, 1967*, Peoria, Illinois. The Peoria Art Guild of Lakeview Center for the Arts and Sciences, no. 13, p. 16.

Chronology

Age	Year	LILLIE MAY NICHOLSON
	1884	Born August 29, Nicholson Ranch, San Juan Road, Carneros, Dunbarton, Watsonville, California
9	1893	Commences grade school (nine years), Carneros School near Aromas
18	1902	Pencil sketches
19	1903(?)	Moves to San Jose, to attend Normal School
20	1904(?)	A book: *New Essentials of Book-keeping,* by Childs, is monogrammed LMN and gives her address as Carneros, CA
22	1907	June 21: graduates from the California State Normal School for Teaching, San Jose, California (had lived with maternal grandparents, Mr. and Mrs. Cole)
23	1907	Teaches at Rock School, Aromas, California
24	1908	Teaches in Honolulu, Hawaii (photo aboard battleship *Wisconsin,* July).
25	1909	Returns in mid-year, 1909
26	1910	Teaches in Watsonville, Santa Cruz County. Studies water color, Watsonville, with L. Minnie Pardee
27	1911	To Japan, December 1911 or early 1912
28	1912	Teaches school at Kyoto. Painting teacher is
29	1913	J. Taguchi (painting by J. Taguchi, 1913, given to niece, June K. Wright, around 1945).
30	1914	Death of father, Murdoch Nicholson, December 19
31	1915	Theft in Hong Kong Harbor on return from Europe to Japan
32	1916	Full-time teacher, Santa Clara grade school or high school. Registers for first time, July 16, San Francisco Institute of Art (SFIA) summer session.
32	1917	Teaches in Santa Clara. Summer sessions, SFIA

Age	Year	
33	1918	Photo taken by Dorothea Lange in San Francisco (Lange arrived in Bay area 1918)
34	1919	Teaches in Santa Clara, then Oakland, beginning August 19. Summer session, SFIA
35	1920	Teaches in Oakland, California (Longfellow and Allendale Grammar Schools). Summer session, SFIA
		Painting, dated 1920, *Red Houses at Inlet* (Ill. 8)
37	1921	February 1-15: SFIA
		February 19, death of mother, Emma Cole Nicholson
		June, mail returned to SFIA from Delmar Inn, 15th and Jackson, Oakland, California
		According to correspondence she is in London, June 24
		Scotland, July 15 (Nicolson Institute, Stornoway)
		Paris, December 11 (Disarmament Conference, Washington, D.C.). Travels, paints and studies in Europe: England, Paris, Etaples, Naples, Venice
38	1922	Shanghai, June 6 (probably en route home

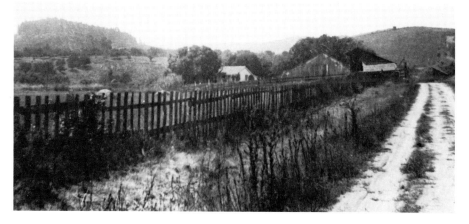

55. The Nicholson Ranch, near Aromas, California. Photograph taken about 1930.

Age	Year	
		from Europe). Stops teaching school in Oakland (did not get leave of absence)
39	1923	Opens studio at 667 Lighthouse Avenue, Pacific Grove, California. Entry for California Industries Exhibition: *Fishing Boats after the Shower, Etaples* (see page 46 and Cat. No. 46)
39	1924	First entry (in Guest Book) of visitor to studio, July 12: September 13, Bertha Stringer Lee, 2744 Steiner Street, San Francisco
40	1924	October 25: visit of Jeanette Maxfield Lewis, Fresno, in Guest Book
	1925	April 3: receives California Life Diploma, Oakland (Alameda County) from Superintendent
40	1925	May 1: visit of a Mrs. O. P. Thompson, Atwater, Ohio, in Guest Book
		June 15, studio re-opens
41	1925	September 28: visit of Edith Dangerfield, Pacific Grove
		October 3: Paul DeWolf, in Guest Book
		October 17: Mr. DeWolf, in Guest Book
		October 23: Paul DeWolf, 891 Senix, Pacific

56. SLOPE, SPRINGTIME, PACIFIC GROVE (Cat. No. 71)

Age	Year	
		Grove, in Guest Book
		October 28: Mr. DeWolf, in Guest Book
41	1926	January 6: marriage (age stated as thirty-three) to Paul DeWolf, forty-two, a builder, of Pacific Grove, in Salinas, California (he for the second time, she for the first time)
		February: receives parcel addressed to Mrs. Lillie Nicholson DeWolf, 663 Lighthouse Avenue, Pacific Grove
		May 29: requests and receives letter of SFIA as Lillian Nicholson DeWolf
		June 9: agreement, Santa Cruz County, to live apart, receive alimony and quit claim on respective property
43	1927	Label for Arizona State Fair, Art Exhibition, attached to reverse of *Fishing Boats, Venice.* (see Ill. 3)
		December 13: "hurt by auto"— reference to being hit by a car as a pedestrian
43	1928	February 1-15: label for First Annual Exhibition Santa Cruz Art League on *Fishing Boats, Venice* (attached to reverse). The same painting as mentioned above
		May 22: entry in Guest Book from Roberta Balfour Thudrechan "To my comrade of the Rainbow Trail with deep admiration always" (reference, perhaps, to Yosemite where she visited, according to postal cards sent from there)
		July 21: L. Minnie Pardee, San Jose, California, in Guest Book. Early teacher in water colors.
44	1929	May 15: Visit of "six from Watsonville Art Club"
		May 19: Mr. and Mrs. Russell (Margaret) Witter, Oakland (later in San Francisco, June 19, 1932), in Guest Book
		June 19: Bertha Stringer Lee, 2744 Steiner, San Francisco, in Guest Book
		June 24: B. S. Lee and L. Eugene Lee, in Guest Book
		August 16: Jeanette Maxfield Lewis, in Guest Book

Age	Year	
		August 24: Nellie B. Evey, Watsonville, in Guest Book
45	1930	August 4: James G. Merks, *Monterey Peninsula Herald,* in Guest Book
46		September 10: B. S. Lee, in Guest Book
46	1931	March 19: K. Boynton, Pebble Beach, in Guest Book
		June 12: B. S. Lee, in Guest Book
47		September 13: David A. Boronda, 251 Alvarado, Monterey, in Guest Book
48	1932	December: studio closed until April 16, 1933
48	1933	April 16: studio closed until Septmeber, 1938
49	1934	May: Sketch Book of small pencil sketches indicates her residence in Oakland, California. Sketches mainly people in "court, library, stock (market?)"
53	1937	July 12: Sketches located at: *Lake Merritt, Lake Chabaud (sic), Giddings Way Station*
54	1938	September: studio reopens in Pacific Grove
		October 1 and 2: Open House
		October 20: L. M. Carpenter, Pebble Beach (formerly Berkeley), in Guest Book
		December 16: last entry in Guest Book

57. Studio at 667 Lighthouse Avenue, corner of Park Street, Pacific Grove. (Photographed shortly before building was moved to new site in 1979). Photo: Pat Hathaway, Pacific Grove, California.

Age	Year	
	Year Unknown	Moves to Oakland again (perhaps to Sutter Hotel, P.O. Box 644, Oakland, 4, California)
59	1943	October 23: completes three hundred sixth-eight hours training as Aircraft Engine Mechanic, Alameda Board of Education, Motor School, 1308 Union Street, Alameda; works, presumably at U.S. Naval Air Station, Alameda, California
60	1944	December 27: U.S. Naval Air Station, Alameda. Completes thirty-two hour course in Aircraft Overhaul and Inspection
60	1945	February: U.S. Naval Air Station, Alameda. Completes thirty-two hours in Aircraft Engine Inspection
		February: as Mechanic's Helper at maximum (wage) submits suggestion (with drawing)
		April/May: gets award (photo, May 2, 1945, with Commodore)
62	1946	Mail, c/o Bank of America, Securities Department, 12th and Broadway, Oakland
63	1947	Attempts to burn and destroy paintings which had been stored in wash house at ranch near Aromas, but is prevented from doing so
65	1949	November: snap photo on street in Oakland (Metro Movie Shot)
		Summer: photos on Nicholson Ranch
66	1950	Receives etching from Jeanette Maxfield Lewis, Fresno, at P.O. Box 644, Oakland, 4, California
69	1953	Postcards to P.O. Box 644, Oakland 4
77	1961	Etching from J. M. Lewis, now at Pebble Beach to P.O. Box 644
	1963	July: photo at picnic in Big Trees, Santa Cruz Mountains, California
		In hospital, two or three months before death (according to her niece)
80	1964	Dies November 28, 6:30 p.m., Sutter Hotel, Room 517, 14th and Jefferson, Oakland, California; found by Wallace McMillan, night clerk. (W. McMillan, 1979).
	1964	December 2: is buried, Pioneer Cemetery, Watsonville

58. Sutter Hotel, Oakland.
(Photographed in 1979.)

59. CUSTOM HOUSE, MONTEREY
(Cat. No. 77)

Catalog of Known Works

The paintings in the catalog are arranged in chronological order with medium, support, subject matter and stylistic considerations substituting for dates and locales which were infrequently provided by the artist. The dimensions are given in inches with height of the work preceding the width. The signature, when present, is commonly L. M. Nicholson. In one instance (Cat. No. 271) there appears the monogram L.M.N.; in several instances she used the initials L.N. One painting she signed L. Nicholson (Cat. No. 133). A number of paintings appear back-to-back; both subjects are described and listed separately, usually one after the other. In some instances, it is clear that different locales are featured on opposite sides of the work (see for instance Cat. Nos. 33-34 and 329-330).

In most instances the works listed in the Catalog were obtained directly from the artist or from her estate. Where known, previous owners are listed in order to establish provenance. The persons and institutions owning works at the time of this writing are gratefully acknowledged herewith.

Mr. and Mrs. Burt Avery
Atherton, California

George R. Bobbitt
San Francisco, California

Mr. and Mrs. Jess W. Braucht
Carmel, California

Charlotte Berberick
Hollister, California

James L. Coran
Oakland, California

James T. Duff
Silver Spring, Maryland

Lila Elliott
Hollister, California

Mr. and Mrs. Henry P. Henrichsen
Watsonville, California

Margaret H. Houghton
Hollister, California

Mrs. Nell Kortright Evey
San Francisco, California

Brian T. Hourican
Oakland, California

D. Clinton Hynes, Fine Art, Inc.
Chicago, Illinois

Mrs. Katherine E. Lake
Pacific Grove, California

Mary Lu and Tom Lowe
Lafayette, California

Erik J. Martin
Oakland, California

Scott Vincent Monroe
Alamo, California

Monterey Peninsula Museum of Art
Monterey, California

Walter A. Nelson-Rees
Oakland, California

Barbara Nicholson
Watsonville, California

Bill Nicholson
Watsonville, California

Emma H. Nicholson
Watsonville, California

Joan Vivian Nopp
Lafayette, California

The Oakland Museum
Oakland, California

Gaylene E. Pearson
Lafayette, California

Helen Saunders
Oakland, California

Captain and Mrs. John L. Sechler
Lafayette, California

The Sohlman Art Gallery
Oakland, California

Ethel Wilson
San Jose, California

June K. Wright
Sacramento, California

PAINTINGS IN WATER COLOR

1. VIOLETS
 Water color on paper
 6 x 12 (sight)
 Not signed
 Nell K. Evey

2. TWO CARNATIONS AND BUD
 Water color on paper
 12 x 6½
 Not signed
 June K. Wright

3. APPLE BLOSSOMS AND BUDS
 Water color on paper
 12 x 8½
 Not signed
 June K. Wright

4. WATER AND TREE, FALL
 Water color on paper
 9½ x 13¾
 Not signed
 Emma H. Nicholson

5. OLD SINGLE ROSES; Cherokee?
 Water color on paper
 6½ x 17½
 Not signed
 Emma H. Nicholson

6. COUNTRY ROAD AND FENCE
 Water color on paper
 7½ x 12
 Not signed
 Bill and Barbara Nicholson

PENCIL SKETCHES

7. HEAD AND NECK OF
 WOMAN; Plus study of head
 Charcoal on paper (Ingres)
 24¾ x 18¾
 Not signed
 W. A. Nelson-Rees; J. L. Coran

8. THREE STUDIES OF WOMEN;
 Two standing, one seated
 Charcoal on paper MBM (France)
 18¾ x 24¾
 Not signed
 (On reserve of TWO STUDIES)
 W. A. Nelson-Rees; J. L. Coran

9. TWO STUDIES; Back of head of
 woman; also side view (profile)
 Charcoal on paper MBM (France)
 18¾ x 24¾
 Not signed
 (On reverse of THREE STUDIES
 OF WOMEN)
 W. A. Nelson-Rees; J. L. Coran

10. PROFILE OF WOMAN
 Charcoal on paper MBM (France)
 18¾ x 13½
 Not signed
 W. A. Nelson-Rees; J. L. Coran

11. PROFILE AND BUST OF WOMAN
 Charcoal on paper Michallet
 (France)
 Marked "4"
 24½ x 18½
 Not signed
 W. A. Nelson-Rees; J. L. Coran

12. STUDY OF BOY WITH TIE; Head
 and bust
 Charcoal on paper MBM (France,
 Ingres, D. Arches)
 24¾ x 18¾
 Not signed
 (On reverse of LAUGHING
 CHILD)
 W. A. Nelson-Rees; J. L. Coran

13. LAUGHING CHILD; Terra cotta bust?
 (Double, on half page of back)
 Charcoal on paper
 18¾ x 24¾
 Not signed
 On reverse of STUDY OF BOY
 WITH TIE
 W. A. Nelson-Rees; J. L. Coran

14. TWO MALE HEADS; Statues,
 side-by-side
 Charcoal on paper MBM (France)
 24¾ x 18¾
 Not signed
 W. A. Nelson-Rees; J. L. Coran

15. NUDE MALE; With loin cloth,
 holding spear
 Charcoal on paper MBM (France)
 24¾ x 18¾
 Not signed
 (On reverse of HEAD OF ARAB)
 W. A. Nelson-Rees; J. L. Coran

16. HEAD OF ARAB (?)
 Charcoal on paper MBM (France)
 24¾ x 18¾
 Not signed
 (On reverse of NUDE MALE)
 W. A. Nelson-Rees; J. L. Coran

17. HEAD AND BUST OF OLD MAN
 WITH BEARD
 Charcoal on paper (Ingres) PMF (Italia)
 24¾ x 19
 Signed center right
 W. A. Nelson-Rees; J. L. Coran

18. WOMAN IN RIDING HABIT
 SEATED ON STOOL; Marked "7"
 Charcoal on paper MBM (France)
 24¾ x 18¾
 Not signed
 W. A. Nelson-Rees; J. L. Coran

19. HEAD OF WOMAN; Buttoned
 blouse
 Charcoal on paper (Ingres,) PMF
 (Italia)
 24¾ x 18¾
 Not signed
 (On reverse of UNFINISHED
 STUDY OF MALE HEAD)
 W. A. Nelson-Rees; J. L. Coran

20. UNFINISHED STUDY OF MALE
 HEAD; Bald
 Charcoal on paper PMF (Italia)
 24¾ x 18¾
 Not signed
 (On reverse of HEAD OF
 WOMAN)
 W. A. Nelson-Rees; J. L. Coran

OIL PAINTINGS
San Francisco-Lake Tahoe, California

21. COASTAL SCENE (Probably
 among first paintings)
 Oil on board
 9 x 12 (Framed in San Jose)
 Not signed
 W. A. Nelson-Rees; J. L. Coran

22. LANDS END, SAN FRANCISCO
 Oil on board
 12 x 16
 Signed lower left
 W. A. Nelson-Rees; J. L. Coran

23. RED HOUSES AT INLET;
 Mountains beyond (Tamalpais?)
 dated 1920
 Oil on board
 12 x 16
 Signed lower right
 (On reverse: Billy Nicholson,
 June 6, 1937, July 23)
 W. A. Nelson-Rees; J. L. Coran

24. MT. TAMALPAIS FROM TIBURON
Oil on board
12 x 16
Signed lower right
W. A. Nelson-Rees; J. L. Coran

25. MT. TAMAPIAS (sic; her
title); Blue
Oil on board
12 x 16
Signed lower left
W. A. Nelson-Rees; J. L. Coran

26. WEEPING WILLOW AT POND
Oil on speckled artist board
12 x 16
Signed lower right
W. A. Nelson-Rees; J. L. Coran

27. BOATS-BELVEDERE (Her title)
Oil on board
12 x 16
Signed lower right
W. A. Nelson-Rees; J. L. Coran

28. REFLECTIONS, TIBURON (Her title)
Oil on board
12 x 16
Signed lower right
W. A. Nelson-Rees; J. L. Coran

29. MOUNTAIN NEAR LAKE TAHOE
Oil on board
12 x 16
Signed lower left
W. A. Nelson-Rees; J. L. Coran

30. MOUNTAIN AND LAKE
Oil on canvas board
16 x 12
Signed lower left
W. A. Nelson-Rees; J. L. Coran

31. LAKE TAHOE
Oil on canvas board
12 x 16
Signed lower right
W. A. Nelson-Rees; J. L. Coran
Gaylene E. Pearson

32. MT. TALAC, LAKE TAHOE (sic;
her title)
Oil on board
12 x 16
Signed lower right
W. A. Nelson-Rees; J. L. Coran

San Francisco—Etaples, France

33. LANDS END, S.F. (sic; her title)
Oil on board
12 x 16
Not signed
(On reverse of CHILDREN,
ETAPLES, FRANCE)
W. A. Nelson-Rees; J. L. Coran

34. CHILDREN, ETAPLES, FRANCE
(Her title)
Oil on board
12 x 16
Signed lower left
(On reverse of LANDS END, S.F.)
W. A. Nelson-Rees; J. L. Coran

35. MT. TAMALPAIS
Oil on board
15½ x 11½
Not signed
(On reverse of SAILING
VESSELS AT ETAPLES)
W. A. Nelson-Rees; J. L. Coran

36. SAILING VESSELS AT ETAPLES
(Her location)
Oil on board
11½ x 15½
Signed lower right and located
(On reverse of MT. TAMALPAIS)
W. A. Nelson-Rees; J. L. Coran

Etaples, France

37. BOY AT HOUSES; Etaples
Oil on board
10½ x 15½
Not signed
(On reverse of WOMAN WITH
HAT)
W. A. Nelson-Rees; J. L. Coran
Captain and Mrs. John L. Sechler

38. WOMAN WITH HAT; Seated
Oil on board
15½ x 10½
Not signed
(On reverse of BOY AT HOUSES)
W. A. Nelson-Rees; J. L. Coran
Captain and Mrs. John L. Sechler

39. RIVER AT ETAPLES, FRANCE
(Canche)
(Was framed; titled: "Near
Etaples, France")
Oil on canvas laid on board
5⅞ x 15⅝
Signed lower right
W. A. Nelson-Rees; J. L. Coran

40. ETAPLES IN THE MOONLIGHT
(France)
Oil on wooden panel
10½ x 13¾
Signed lower right
W. A. Nelson-Rees; J. L. Coran

41. NIGHT-ETAPLES, FRANCE (Her
title)
Oil on board
10½ x 15
Not signed
(On reverse of HOUSES AT
WATER'S FRONT)
W. A. Nelson-Rees; J. L. Coran

42. HOUSES AT WATER'S FRONT;
Sailboats beyond (Etaples)
Oil on board
10½ x 15
Not signed
(On reverse of NIGHT-ETAPLES,
FRANCE)
W. A. Nelson-Rees; J. L. Coran

43. ETAPLES AT NIGHT; Waterfront
Oil on canvas
18 x 24
Not signed
W. A. Nelson-Rees; J. L. Coran

44. RIVER AT ETAPLES (Canche)
Oil on board
10⅝ x 15½
Signed lower right
W. A. Nelson-Rees; J. L. Coran

45. SAILBOATS (Etaples); In waterway
Oil on wooden board or cardboard
8¾ x 11½ (sight)
Not signed
June K. Wright

46. FISHING BOATS AFTER THE
SHOWER; Etaples, France
Oil on canvas, lined
18 x 24
Signed lower right
(Label on reverse: California
Industries Exhibition, Artist's
Exhibit 1923)
Bill and Barbara Nicholson

47. CHILD AT SEA WALL (Etaples)
Oil on wooden panel
14 x 10½
Signed lower left
Bill and Barbara Nicholson
W. A. Nelson-Rees; J. L. Coran

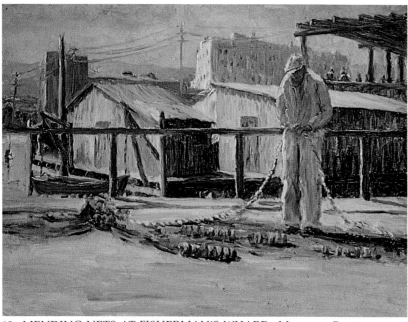

60. MENDING NETS AT FISHERMAN'S WHARF. Monterey Boating Clubhouse at right; San Carlos Hotel right background. (Cat. No. 104)

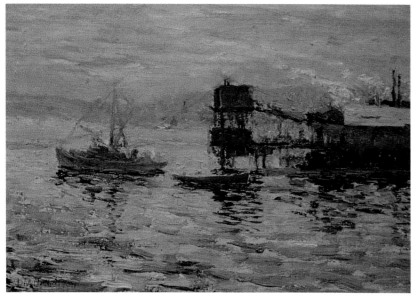

61. FISHING BOATS TRANSFERRING CATCH, MONTEREY BAY (Cat. No. 246)

48. HAYSTACKS, ETAPLES; (Her title, lower left in pencil); Also shows poplars
 Oil on board
 10¾ x 15½
 Signed lower right
 June K. Wright

49. HAYSTACKS, FRANCE
 Oil on board
 7 x 10½
 Signed lower right
 June K. Wright

50. LANDSCAPE NEAR ETAPLES, FRANCE (?)
 Oil on board
 13 x 6½
 Signed lower center right
 Margaret H. Houghton

51. TWO FRENCH CHILDREN AT ETAPLES
 Oil on wooden board
 14 x 10½
 Signed lower left
 (On reverse of CALIFORNIA HILLS AT RESERVOIR)
 W. A. Nelson-Rees; J. L. Coran

52. CALIFORNIA HILLS AT RESERVOIR
 Oil on wooden board
 10½ x 14
 Not signed
 (On reverse of TWO FRENCH CHILDREN AT ETAPLES)
 W. A. Nelson-Rees; J. L. Coran

53. SILENT SENTINELS, NORTHERN FRANCE
 Oil on wooden board
 10½ x 10
 Signed lower right
 Emma H. Nicholson

54. COUNTRY HOME, NORTHERN FRANCE
 Oil on wooden panel
 13½ x 10½
 Signed lower right
 Bill and Barbara Nicholson

Paris, France

55. PAVILLON DE FLORE, LOUVRE
 Oil on board
 12 x 16
 Not signed
 (On reverse of SELF PORTRAIT)
 W. A. Nelson-Rees; J. L. Coran

56. SELF PORTRAIT; Of artist along
 the Seine
 Oil on board
 12 x 16
 Not signed
 (On reverse of PAVILLON DE
 FLORE, LOUVRE)
 W. A. Nelson-Rees; J. L. Coran

57. FRENCH STREET SCENE IN
 THE RAIN
 Oil on board
 16 x 6½
 Signed lower right
 Bill and Barbara Nicholson

Venice, Italy

58. BOAT AT CITY SHORE
 (Pontillism)
 Oil on board
 10¾ x 15½
 Signed lower right
 June K. Wright

59. VENICE HARBOUR SCENE;
 TWO-MASTED SAILBOAT
 Oil on board
 14 x 9½
 Signed lower right
 June K. Wright

60. FISHING BOATS, VENICE (?)
 Oil on board
 14 x 10½
 Not signed
 June K. Wright

61. FISHING BOATS, VENICE,
 ITALY (Her title)
 Oil on board
 13¾ x 10½
 Signed lower left
 Label on reverse: Art Exhibit,
 Arizona and Santa Cruz, 1928
 W. A. Nelson-Rees; J. L. Coran

62. VENICE CANAL
 Oil on board
 10½ x 13½
 Signed lower left
 Emma H. Nicholson

63. ST. GEORGE, VENICE
 Oil on wooden panel
 14½ x 10½
 Signed lower left
 Emma H. Nicholson

64. STREET SCENE, VENICE,
 ITALY; Canal
 Oil on canvas, lined
 21½ x 18
 Signed lower right
 Bill and Barbara Nicholson

65. SAILING VESSELS, VENICE
 (Was framed)
 Oil on board
 10⅝ x 7¼
 Signed lower left
 (On reverse of PATH UNDER BIG
 TREES)
 W. A. Nelson-Rees; J. L. Coran

66. PATH UNDER BIG TREES
 Oil on board
 10⅝ x 7¼
 Signed lower right
 (On reverse of SAILING
 VESSELS, VENICE)
 W. A. Nelson-Rees; J. L. Coran

Pacific Grove, California

67. THREE BOATS; One lampara
 fishing boat with two men working
 Oil on canvas, lined
 11¾ x 15½
 Not signed
 W. A. Nelson-Rees; J. L. Coran

68. MENDING NETS EAST SIDE,
 FISHERMAN'S WHARF,
 LOOKING SOUTH; Cars
 Oil on canvas, lined
 11 x 15½
 Not signed
 The Oakland Museum, gift of
 W. A. Nelson-Rees; J. L. Coran

69. THREE MEN MENDING NETS;
 Fisherman's Wharf, Monterey,
 looking east
 Oil on canvas, lined
 14¾ x 11⅛
 Signed lower right
 Monterey Peninsula Museum of Art,
 Gift of W. A. Nelson-Rees; J. L. Coran

70. MENDING NETS ON RACKS;
 Fisherman's Wharf, east side
 looking north
 Oil on canvas, lined
 11⅛ x 15½
 Not signed
 W. A. Nelson-Rees; J. L. Coran

71. SLOPE, SPRINGTIME, PACIFIC
 GROVE
 Oil on board
 7¾ x 11¾
 Signed lower right
 (On reverse of painter's study)
 W. A. Nelson-Rees; J. L. Coran

72. GREEN BOAT AT PIER
 Oil on board
 11½ x 16
 Signed lower right
 W. A. Nelson-Rees; J. L. Coran

73. WOODLAND SCENE, PACIFIC
 GROVE
 Oil on canvas board
 16 x 12
 Signed lower right
 W. A. Nelson-Rees; J. L. Coran

74. DUNES WITH RED FLOWERS
 Oil on board
 8½ x 11¾
 Signed lower right
 (On reverse of BLUE GROVE)
 W. A. Nelson-Rees; J. L. Coran

75. BLUE GROVE
 Oil on board
 8½ x 11¾
 Not signed
 (On reverse of DUNE WITH RED
 FLOWERS)
 W. A. Nelson-Rees; J. L. Coran

76. RAISING NETS TO TRUCK
 Oil on canvas laid on board
 16 x 11⅞
 Signed lower left
 W. A. Nelson-Rees; J. L. Coran

77. CUSTOM HOUSE, MONTEREY
 Oil on unstretched canvas
 10¼ x 8¼
 Not signed
 (On reverse of SAND DUNES)
 W. A. Nelson-Rees; J. L. Coran

78. SAND DUNES
 Oil on unstretched canvas
 10¼ x 8¼
 Signed lower right
 (On reverse of CUSTOM
 HOUSE, MONTEREY)
 W. A. Nelson-Rees; J. L. Coran

79. TIME OUT FOR CARDS
Oil on board
12 x 16
Signed lower left
W. A. Nelson-Rees; J. L. Coran

80. TWO MEN; One on left in blue
suit, green hat
Oil on board
12 x 16
Signed lower center
W. A. Nelson-Rees; J. L. Coran

81. LAUNDRY OUT TO DRY; Cabin
on left
Oil on board
12 x 16
Signed lower right
W. A. Nelson-Rees; J. L. Coran

82. FIVE MEN MENDING NETS (On
sidewalk?); Palm on the left
Oil on board
12 x 16
Signed lower left
W. A. Nelson-Rees; J. L. Coran

83. SIX MEN MENDING NETS;
Green wall at right rear
Oil on board
12 x 16
Signed lower left
W. A. Nelson-Rees; J. L. Coran

84. CYPRESS AND VIEW OF BAY
Last painting (?), found in one of her
2 paint boxes
Oil on board
16 x 12
Signed lower right
W. A. Nelson-Rees; J. L. Coran

85. SPIDER WEB NET; Man on right
with yellow shirt and pipe
Oil on board
12 x 16
Signed lower right
W. A. Nelson-Rees; J. L. Coran

86. TWO BOYS — CALIFORNIA (Her title)
Oil on board
12 x 16
Signed lower right
W. A. Nelson-Rees; J. L. Coran
Mary Lu and Tom Lowe

87. GIRL WITH UMBRELLA AND
ROCKY SHORE
Oil on board
11½ x 15¾
Not signed
W. A. Nelson-Rees; J. L. Coran
Mary Lu and Tom Lowe

88. ONE-MAN FISHING BOATS AT
ANCHOR; Three men at work
Oil on board
16 x 12
Not signed
W. A. Nelson-Rees; J. L. Coran

89. THREE MEN ON YELLOW DOCK;
One seated on log; pot hanging
Oil on canvas, lined
11½ x 15½
Signed lower right
W. A. Nelson-Rees; J. L. Coran

90. FIVE MEN MENDING NETS;
Water and high hills beyond
Oil on canvas, lined
16 x 11½
Signed lower right
W. A. Nelson-Rees; J. L. Coran

91. TWO MEN ON WHARF
MENDING NETS; Five Model-T
Fords on wharf
Oil on canvas, lined
11½ x 15
Not signed
W. A. Nelson-Rees; J. L. Coran

92. STRANDED FOR REPAIRS
Oil on board
12 x 16
Not signed
W. A. Nelson-Rees; J. L. Coran

93. SIX CHILDREN ON SHORE
Oil on board
12 x 16
Signed lower left
W. A. Nelson-Rees; J. L. Coran

94. STEAMER DEPARTING
Oil on board
12 x 16
Signed lower right
W. A. Nelson-Rees; J. L. Coran

95. MONTEREY PIER, BAY,
MOUNTAINS AND CLEAR SKY
Oil on board
12 x 16
Signed lower left
W. A. Nelson-Rees; J. L. Coran

96. WHARF NUMBER TWO; Eight
boats at anchor
Oil on board
12 x 16
Signed lower right
W. A. Nelson-Rees; J. L. Coran

97. TWO DINGHYS IN MONTEREY
BAY
Oil on board
12 x 16
Signed lower right
W. A. Nelson-Rees; J. L. Coran
Brian T. Hourican; Erik J. Martin

98. FIVE MEN MENDING NETS;
One standing (behind cannery)
Oil on board
12 x 16
Signed lower right
W. A. Nelson-Rees; J. L. Coran

99. SANDY COAST WITH COLOR
SPOT; Haze and perfect sky
Oil on board
12 x 16
Signed lower right
W. A. Nelson-Rees; J. L. Coran
Gaylene E. Pearson

100. FIVE FISHERMEN MENDING
NETS BEHIND CANNERY ROW;
Three boats in bay in background
Oil on board
12 x 16
Not signed
W. A. Nelson-Rees; J. L. Coran

101. TRANSFER OF CATCH,
CANNERY ROW
Oil on board
12 x 16
Not signed
W. A. Nelson-Rees; J. L. Coran

102. FOUR FISHERMEN AT WORK;
One in pink shirt
Oil on board
16 x 12
Not signed
W. A. Nelson-Rees; J. L. Coran

103. SEVEN BOATS AT ANCHOR;
Wharf No. 2 in rear
Oil on board
12 x 16
Not signed
W. A. Nelson-Rees; J. L. Coran

104. MAN MENDING NETS AT
FISHERMAN'S WHARF; Boating
Club and San Carlos Hotel beyond
Oil on board
12 x 16
Not signed
W. A. Nelson-Rees; J. L. Coran

105. SEA BIRDS, MONTEREY
Oil on board
12 x 16
Signed lower left
W. A. Nelson-Rees; J. L. Coran

106. BOY IN BLUE JUMPER, RED TRIM
Oil on board
12 x 16
Signed lower center
W. A. Nelson-Rees; J. L. Coran

107. FISHERMEN MENDING NET,
MONTEREY WHARF (Her title)
Oil on canvas
16 x 20
Not signed
W. A. Nelson-Rees; J. L. Coran

108. MAN SEATED AT BAY PARK
NEAR CUSTOM HOUSE
OVERLOOKING WATER AND
MOUNTAINS
Oil on canvas, lined
16 x 20
Signed lower left
W. A. Nelson-Rees; J. L. Coran
Scott Vincent Monroe

109. FISHING "COMPETITION,"
MONTEREY WHARF
Oil on board
12 x 16
Signed lower right
W. A. Nelson-Rees; J. L. Coran

110. FOUR MEN MENDING NETS
NEAR WHITE HOUSE
Oil on *reverse* of canvas board
12 x 16
Not signed
W. A. Nelson-Rees; J. L. Coran

111. THREE MEN; One in center with
pipe, at crab pot
Oil on board
12 x 16
Signed lower left
W. A. Nelson-Rees; J. L. Coran

112. TWO MEN, SEATED, MENDING;
Green crab pot and drums beyond
Oil on board
12 x 16
Signed lower left
W. A. Nelson-Rees; J. L. Coran

113. FIVE FISHERMEN MENDING
NETS NEAR SQUARE FRAME
Oil on board
12 x 16
Signed lower right
W. A. Nelson-Rees; J. L. Coran
D. Clinton Hynes, Fine Art, Inc.

114. FISHERMEN MENDING NETS
ON MONTEREY WHARF; Car in
background, looking south
Oil on board
12 x 16
Signed lower right
W. A. Nelson-Rees; J. L. Coran
The Sohlman Art Gallery

115. TWO MEN SEATED ON PIER;
Four boats; buildings on left
shore (Cannery Row)
Oil on board
12 x 16
Signed lower left
W. A. Nelson-Rees; J. L. Coran
Mr. and Mrs. Burt Avery

116. THREE SEATED FISHERMEN
ON MONTEREY WHARF
MENDING NETS; House at
Booth's through passageway
Oil on board
12 x 16
Signed lower right
W. A. Nelson-Rees; J. L. Coran

117. BLUE BAY; Five boats with pink-
topped mountains beyond
Oil on board
12 x 16
Signed lower right (very lightly)
W. A. Nelson-Rees; J. L. Coran

118. GREEN SHORE, BEACH AND
BLUE BAY
Oil on board
12 x 16
Signed lower left
W. A. Nelson-Rees; J. L. Coran

119. THREE FISHERMEN, LARGE
NETS, AT WORK ON BOAT
Oil on board
12 x 16
Signed lower right
W. A. Nelson-Rees; J. L. Coran

120. MAN SEATED; Blue sweater,
purple tie; man on boat in water
Oil on board
12 x 16
Signed lower right
W. A. Nelson-Rees; J. L. Coran

121. FIVE FISHERMEN MENDING
NETS, AT FISHERMAN'S
WHARF; Three sitting, by Booth
cannery and shore beyond
Oil on board
12 x 16
Signed lower right
W. A. Nelson-Rees; J. L. Coran

122. GREEN BOAT AT PIER; White
captain's bridge
Oil on canvas board
12 x 16
Not signed
W. A. Nelson-Rees; J. L. Coran

123. ONE-MAN FISHING BOAT,
COAST LINE BEYOND
Oil on canvas
16 x 20
Signed lower left
W. A. Nelson-Rees; J. L. Coran

124. THREE FISHERMEN SEATED
MENDING NETS
Houses on shore
Oil on board (gash in the sky)
12 x 16
Signed lower left
W. A. Nelson-Rees; J. L. Coran

125. COLORFUL PRECIPICE ON
LEFT; ROCKS ON COAST
Oil on board
12 x 16
Signed lower right
W. A. Nelson-Rees; J. L. Coran
George R. Bobbitt

126. BLUE HALF RING BOAT AT
PIER PILINGS
Oil on board
12 x 16
Not signed
W. A. Nelson-Rees; J. L. Coran

127. MONTEREY WHARF
BUILDINGS (West side); From
Booth Cannery Pier
Oil on board
12 x 16
Not signed
W. A. Nelson-Rees; J. L. Coran

128. WHARF SCENE, MONTEREY;
With fishing boats
Oil on board
12 x 16
Signed lower left
W. A. Nelson-Rees; J. L. Coran

129. FOUR MEN STANDING,
MENDING NETS AT OPEN
DOOR; Two seated in
background (red kerchief).
Small boat center left
Oil on board
12 x 16
Signed lower right
W. A. Nelson-Rees; J. L. Coran

130. TWO MEN SEATED, MENDING
NETS; Near two (water?) storage
towers; east side, Monterey
Wharf. Blue cart at left
Oil on board
12 x 16
Not signed
W. A. Nelson-Rees; J. L. Coran

131. TWO MEN SEATED, MENDING
NETS; One tower (water?)
Oil on board
12 x 16
Signed lower left
W. A. Nelson-Rees; J. L. Coran

132. FOUR MEN, ONE STANDING;
Mending nets under (water?)
tower; large pile of nets
Oil on board
12 x 16
Signed lower right
W. A. Nelson-Rees; J. L. Coran

133. FERRANTE'S LANDING; North
of Custom House; three men
mending nets
Oil on canvas, lined
12 x 13½
Signed lower right "L.
Nicholson"
W. A. Nelson-Rees; J. L. Coran

134. FOUR MEN; Two seated at edge
of wharf mending nets;
mountains beyond
Oil on canvas laid on board
11¼ x 15¼
Signed lower left
W. A. Nelson-Rees; J. L. Coran

135. FIVE MEN MENDING NETS; At
end of Monterey Wharf; one
man at auto
Oil on canvas, lined
11¼ x 15¾
Signed lower right
W. A. Nelson-Rees; J. L. Coran

136. OAK GROVE
Oil on canvas laid on board
11 x 15
Signed lower right
W. A. Nelson-Rees; J. L. Coran

137. MAN AT TABLE (Salesman?)
WITH BASKET OR BOWL;
Wharf No. 2 beyond (?)
Oil on canvas laid on board
10½ x 7½
Signed lower right "LN"
W. A. Nelson-Rees; J. L. Coran

138. EIGHT MEN MENDING NETS;
On boat, near rope ladder
Oil on canvas laid on board
15½ x 11½
Signed lower right
W. A. Nelson-Rees; J. L. Coran

139. SEVEN MEN MENDING NETS
ON HILL NEAR TREES
Oil on canvas
14 x 10¼
Signed lower right
(On reverse of MAN ON
WHARF, see portraits, no. 310)
W. A. Nelson-Rees; J. L. Coran

140. MENDING NETS ON
MONTEREY WHARF; Near
wharf fingers; mountains beyond
Oil on board
12 x 16
Signed lower right
W. A. Nelson-Rees; J. L. Coran

141. FOUR FISHERMEN; Two
kneeling; mending nets near
boat at wharf-side
Oil on canvas
12 x 16
Signed lower right
W. A. Nelson-Rees; J. L. Coran

142. FIVE MEN MENDING NETS;
Near building; left man in blue
hip boots
Oil on canvas
12 x 16
Signed lower right
W. A. Nelson-Rees; J. L. Coran

143. FIVE MEN MENDING NETS;
Wharf in front of an anchor
Oil on board
12 x 16
Signed lower right
W. A. Nelson-Rees; J. L. Coran

144. SANDY BEACH AND MT. TORO
Oil on canvas on board
11½ x 15¼
Signed lower right
W. A. Nelson-Rees; J. L. Coran

145. TWO MEN MENDING NETS;
Seated near two oil drums
Oil on board
12 x 16
Signed lower left
W. A. Nelson-Rees; J. L. Coran

146. OLD MAN MENDING NETS;
Near two oil drums
Oil on board
12 x 16
Not signed
W. A. Nelson-Rees; J. L. Coran

147. TWO OLDER MEN, YELLOW
PIPES; Standing mending nets;
three boats and hills beyond
Oil on board
12 x 16
Signed lower right
W. A. Nelson-Rees; J. L. Coran

148. LONE MAN, YELLOW PIPE,
MENDING NETS ON PIER;
Green coast beyond
Oil on board
12 x 16
Signed lower left
W. A. Nelson-Rees; J. L. Coran

149. THREE MEN; One seated
mending nets on wharf; small
boat and pink mountains beyond
Oil on board
12 x 16
Signed lower right
W. A. Nelson-Rees; J. L. Coran

150. TWO MEN; One standing
mending nets on field; houses,
coast, trees and mountains beyond
Oil on board
12 x 16
Signed lower right
W. A. Nelson-Rees; J. L. Coran

151. FOUR MEN MENDING NETS
ON RACK; East side of Monterey
Wharf (end) looking north
Oil on canvas, lined
11¾ x 15½
Signed lower right
W. A. Nelson-Rees; J. L. Coran

152. MANSION, PACIFIC GROVE,
NEAR CANNERY ROW ON
OCEAN
Oil on canvas laid on wooden board
8½ x 11
Signed lower right "LN"
W. A. Nelson-Rees; J. L. Coran

153. FIVE BOATS IN ROUGH SEAS
Oil on canvas on board
11½ x 15¾
Signed lower right
W. A. Nelson-Rees; J. L. Coran
Mr. and Mrs. Jess W. Braucht

154. FOUR MEN MENDING NETS;
Two seated at green doorway
Oil on canvas, lined
15¾ x 11¾
Signed lower right
W. A. Nelson-Rees; J. L. Coran

155. THREE SMALL BOATS AT
ANCHOR; In calm sea
Oil on board
12 x 16
Signed lower right
W. A. Nelson-Rees; J. L. Coran

156. YELLOW COAST AND RUGGED
ROCKS; Mountain range beyond
Oil on board
12 x 16
Signed lower right
W. A. Nelson-Rees; J. L. Coran

157. TWO FISHERMEN MENDING
NETS ON PIER; Square storage
box at water's front
Oil on board (formerly pierced at sky)
12 x 16
Not signed
W. A. Nelson-Rees; J. L. Coran

158. CHORES WHILE DOCKED; Six
fishermen with catch and nets
Oil on board
12 x 16
Signed lower right
W. A. Nelson-Rees; J. L. Coran

159. POPPIES AND GREEN
MOUNDS, SEA BEYOND
Oil on board
12 x 16
Signed lower right
W. A. Nelson-Rees; J. L. Coran

160. PINK SAND DUNES
Oil on board
12 x 16
Signed lower right
W. A. Nelson-Rees; J. L. Coran

161. CLIFF ON RIGHT
Oil on board
12 x 16
Signed lower left
W. A. Nelson-Rees; J. L. Coran

162. SAND DUNES NEAR ASILOMAR
and SAND DUNES, PACIFIC
GROVE (Her titles)
Oil on board
12 x 16
Signed lower right
W. A. Nelson-Rees; J. L. Coran

163. VIEW OF CYPRESS TREES
FROM 17 MILE DRIVE,
MONTEREY PENINSULA
(Her title)
Oil on board
12 x 16
Signed lower right
W. A. Nelson-Rees; J. L. Coran

164. DUNES WITH GREEN AND
BLUE VEGETATION, GREEN
SEA BEYOND
Oil on board
12 x 13
Signed lower right
W. A. Nelson-Rees; J. L. Coran

165. PACIFIC GROVE COAST (Her
title)
Oil on board
12 x 16
Signed lower right
W. A. Nelson-Rees; J. L. Coran

166. ROCKS, PACIFIC COAST (Her
title); Yellow, purple, blue cliffs
Oil on board
12 x 16
Signed lower right
W. A. Nelson-Rees; J. L. Coran

167. THREE PURPLE BOATS, ONE
OARSMAN
Oil on board
12 x 16
Signed lower right
W. A. Nelson-Rees; J. L. Coran

168. FOUR BOATS AT ANCHOR;
Mountain beyond
Oil on board
16 x 12
Signed lower left
W. A. Nelson-Rees; J. L. Coran

169. SEVEN SEATED NET MENDERS;
In open green doorway
Oil on board
12 x 16
Signed lower left
W. A. Nelson-Rees; J. L. Coran

170. PURPLE COAST AT SUNSET
Oil on board
12 x 16
Signed lower right
W. A. Nelson-Rees; J. L. Coran

171. SAND DUNES MONTEREY
PENINSULA (Her title);
White-purple dunes, blue ocean
and purple mountains beyond
Oil on board (scratch in sky)
12 x 16
Signed lower right
W. A. Nelson-Rees; J. L. Coran

172. ROCKS NEAR LIGHT HOUSE, MONTEREY PENINSULA (Her title)
Oil on board
12 x 16
Signed lower right
W. A. Nelson-Rees; J. L. Coran

173. POINT JOE NEAR PACIFIC GROVE (Her title)
Oil on board
12 x 16
Signed lower right
W. A. Nelson-Rees; J. L. Coran

174. VIEW FROM 17 MILE DRIVE, MONTEREY PENINSULA (Her title)
Oil on board
12 x 16
Signed lower right
W. A. Nelson-Rees; J. L. Coran

175. BIT OF COAST, PACIFIC GROVE (Her title)
Oil on board
12 x 16
Signed lower right
W. A. Nelson-Rees; J. L. Coran

176. SEA VIEW, PACIFIC GROVE
Oil on board
12 x 16
Signed lower right
W. A. Nelson-Rees; J. L. Coran

177. MAN STANDING AT BOWL; CANNERY ROW
Oil on board
9 x 10⅝
Not signed
W. A. Nelson-Rees; J. L. Coran

178. PURPLE CLIFFS (Study)
Oil on board
11⅞ x 8⅛
Not signed
W. A. Nelson-Rees; J. L. Coran

179. CARMEL BAY (Was framed and titled this way)
Oil on board
7⅞ x 11⅞
Signed lower left
W. A. Nelson-Rees; J. L. Coran

180. THREE MEN MENDING NETS ON MONTEREY WHARF
Oil on canvas, lined
15 x 11½
Signed lower right
W. A. Nelson-Rees; J. L. Coran

181. SEVEN MEN MENDING NETS ONBOARD; Blue boat; pier beyond
Oil on canvas, lined
12 x 14¾
Signed lower right center
W. A. Nelson-Rees; J. L. Coran
James T. Duff

182. PULLING UP THE NETS
Oil on canvas laid on board
11½ x 15½
Signed lower left
The Oakland Museum, gift of
W. A. Nelson-Rees; J. L. Coran

183. SAND DUNES, YELLOW FLOWERS (Study)
Oil on board
11⅞ x 6½
Signed lower right "LN"
W. A. Nelson-Rees; J. L. Coran

184. WHITE BOAT, DRY DOCK (Study)
Oil on board
11⅞ x 6½
Not signed
W. A. Nelson-Rees; J. L. Coran

185. TWO MEN SEATED ON GRASS MENDING NETS; Cow in background
Oil on board
9 x 10½
Not signed
W. A. Nelson-Rees; J. L. Coran

186. TALL TREES
Oil on board
15½ x 5½
Signed lower right center
W. A. Nelson-Rees; J. L. Coran

187. PINK ROAD THROUGH WOODS
Oil on board
8⅛ x 11⅞
Signed lower right
W. A. Nelson-Rees; J. L. Coran

188. MAN STANDING MENDING NETS; One seated at shore
Oil on board
10 x 12⅝
Signed lower right
W. A. Nelson-Rees; J. L. Coran

189. PURPLE WALL (Study)
Oil on board
11⅞ x 5¼
Signed lower right "LN"
W. A. Nelson-Rees; J. L. Coran

190. SMALL BUILDING, CANNERY ROW; Coast, nets in green meadow
Oil on board
11⅞ x 5¼
Signed lower left "LN"
W. A. Nelson-Rees; J. L. Coran

191. ROCKS IN WATER (Was framed and labeled "EVENING LIGHT, PACIFIC GROVE")
Oil on canvas laid on board
8 x 10½
Signed lower right
W. A. Nelson-Rees; J. L. Coran

192. TWO MEN SEATED MENDING NETS; One yellow-green jacket
Oil on canvas laid on board
10⅜ x 15⅜
Signed lower right
W. A. Nelson-Rees; J. L. Coran

193. FISHING BOAT AT CANNERY ROW
Oil on board
12 x 16
Not signed
(On reverse of BOAT IN WATER WITH FISHERMEN AT PIER)
W. A. Nelson-Rees; J. L. Coran
Joan Vivian Nopp

194. BOAT IN WATER WITH FISHERMEN AT PIER
Oil on board
12 x 16
Signed lower right
(On reverse of FISHING BOAT AT CANNERY ROW)
W. A. Nelson-Rees; J. L. Coran
Joan Vivian Nopp

195. TWO FISHING BOATS AT
ANCHOR
Oil on canvas laid on board
15 x 11½
Not signed
W. A. Nelson-Rees; J. L. Coran

196. FALLEN CYPRESS AT BLUE
INLET
Oil on canvas, lined
17¾ x 24
Signed lower right
W. A. Nelson-Rees; J. L. Coran

197. MENDING NETS; Four fishermen;
two seated, two standing
Oil on canvas, lined
11¾ x 16
Signed lower left
W. A. Nelson-Rees; J. L. Coran

198. FLOWERING DUNES; Center
ocean view
Oil on canvas laid on board
16 x 20
Signed lower right
Margaret H. Houghton

199. SHIP AT DOCK; Five men on board
Oil on board
11½ x 15½
Signed lower left
(On reverse of HORSE AND
CART IN WOODED MEADOW)
Margaret H. Houghton

200. HORSE AND CART IN
WOODED MEADOW
Oil on board
11½ x 15½
Signed lower right
(On reverse of SHIPS AT DOCK)
Margaret H. Houghton

201. FOUR FISHERMEN MENDING
NETS ON DOCK; Two ships and
bay beyond
Oil on board
10½ x 15
Signed lower left
Margaret H. Houghton

202. COASTLINE WITH TREE AT
PRECIPICE (Pontillism)
Oil on board
16 x 12
Signed lower right
(On reverse of FOUR MEN
MENDING NETS)
Margaret H. Houghton

203. FOUR MEN MENDING NETS;
Two seated; large container in
background
Oil on board
12 x 16
Not signed
(On reverse of COASTLINE
WITH TREE AT PRECIPICE)
Margaret H. Houghton

204. BLUE LANDSCAPE; Lupines,
poppies and pine trees
Oil on canvas
16 x 20
Signed lower right
Lila Elliott

205. THREE MONTEREY PINES AT
OCEAN
Oil on board
12 x 16
Signed lower right
Lila Elliott

206. SAND DUNES BACK OF LIGHT
HOUSE (Includes a cypress tree)
Titled on stretcher
Oil on canvas
16 x 20
Signed lower left
Charlotte Berberick

207. SAND DUNES, SEA AND
MOUNTAINS
Oil on board
12 x 16
Signed lower right
(On reverse on stretcher: "Sand
dunes near Asilomar Beach,
Monterey Peninsula")
Charlotte Berberick

208. FISHING BOATS DOCKED; East
side Fisherman's Wharf,
Monterey
Oil on board
10 x 12
Signed lower right
Nell K. Evey

209. TWO BOATS AT ANCHOR;
Green shore beyond (perhaps a
European scene)
Oil on board
7 x 10¼
Signed lower right
June K. Wright

210. ROCKY COAST AT MONTEREY
Oil on board
8½ x 11⅞
Signed lower left
(Double: a painting on back is
covered with paper)
June K. Wright

211. MONTEREY CYPRESS
Oil on board
15½ x 10¾
Signed lower right
June K. Wright

212. DUNES AND LIGHT HOUSE
Oil on board
11½ x 15½
Signed lower right
June K. Wright

213. POINT LOBOS STATE PARK,
GNARLED CYPRESS ON
ROCKY COAST
Oil on board
12 x 16
Signed lower right
June K. Wright

214. ROCKS AND SURF, MONTEREY
Oil on board
7½ x 11¼
Signed lower left
(On back: 12403102)
June K. Wright

215. SIX BOATS AT ANCHOR,
MONTEREY; One man in
dinghy, one on fishing boat
Oil on board
12 x 16
Signed lower right
June K. Wright

216. THREE MEN MENDING NETS;
Four in background, Cannery Row
Oil on board
12 x 16
Not signed
(On reverse of FOUR MEN
MENDING NETS ABOARD SHIP)
June K. Wright

217. FOUR MEN MENDING NETS
ABOARD SHIP
Oil on board
12 x 16
Not signed
(On reverse of THREE MEN
MENDING NETS)
June K. Wright

218. STUDY OF BAY, COAST, WITH
RED ALGAE
Oil on board
11¾ x 5½
Not signed
(On reverse of STUDY OF SAND
DUNES)
June K. Wright

219. STUDY OF SAND DUNES
Oil on board
11¾ x 5½
Not signed
(On reverse of STUDY OF BAY,
COAST, WITH RED ALGAE)
June K. Wright

220. FISHING BOAT AND ROW
BOAT IN BAY
Oil on canvas, unstretched
13¾ x 7½
Not signed
June K. Wright

221. SEVEN MEN MENDING NETS
ON HILL BEYOND CANNERY
ROW
Oil on board
12 x 16
Signed lower right
June K. Wright

222. FLAT COAST OF MONTEREY,
LOOKING EAST
Oil on board
10½ x 11¾
Signed lower right
(On reverse of GINGKO TREE
IN FALL)
June K. Wright

223. GINGKO TREE IN FALL
Oil on board
10½ x 11¾
Not signed
(On reverse of FLAT COAST OF
MONTEREY, LOOKING EAST)
June K. Wright

224. BOATS DISCHARGING NETS
TO TRUCK AT PIER
Oil on canvas laid on board
15½ x 11¼
Not signed
June K. Wright

225. ONE-MAN FISHING BOAT;
Fisherman in yellow; blue
dinghy, red stack
Oil on board
12 x 16
Not signed
June K. Wright

226. MAN STANDING IN ROW BOAT
WITH RED AND YELLOW STRIPES
Oil on board
12 x 16
Signed lower right
June K. Wright

227. ROCKY COAST AT MONTEREY
BAY
Oil on board
12¾ x 10
Signed lower right
June K. Wright

228. FISHING BOAT WITH YELLOW
CHIMNEY
Oil on board
11 x 15
Not signed
Emma H. Nicholson

229. CARMEL CYPRESS
Oil on board
12 x 16
Signed lower right
Emma H. Nicholson

230. BIRDS ON ROCKS
Oil on board
11 x 13½
Signed lower left
Emma H. Nicholson
W. A. Nelson-Rees; J. L. Coran

231. DUNES AND RED POKER PLANT
Oil on board
12 x 16
Signed lower right
Emma H. Nicholson

232. SAND DUNES, PACIFIC GROVE
Oil on board
12 x 16
Signed lower right
Emma H. Nicholson

233. FISHING BOAT AT PIER
Oil on board
12 x 16
Signed lower right
Emma H. Nicholson

234. SPRINGTIME, CARMEL VALLEY
Oil on board
8¼ x 11¾
Signed lower right
Emma H. Nicholson

235. PURPLE MOUNTAINS
Oil on board
8 x 11
Signed lower right
(One of a pair with WILD
FLOWERS AND OCEAN)
Emma H. Nicholson

236. WILD FLOWERS AND OCEAN
Oil on board
8 x 11
Signed lower right
(One of a pair with PURPLE
MOUNTAINS)
Emma H. Nicholson

237. TWO-MASTED FISHING BOAT
Oil on board
12¾ x 6
Not signed
Emma H. Nicholson

238. FISHING PIER AND BOAT WITH
VILLAGE IN BACKGROUND;
Probably Cannery Row
Oil on board
10 x 12½
Signed lower right
Emma H. Nicholson

239. LUPINES, POPPIES AND PINES
Oil on board
10½ x 16
Signed lower right
Emma H. Nicholson

240. MONTEREY PIER
Oil on board
10¼ x 13½
Signed lower left
Emma H. Nicholson

241. PATH TO THE SEA
Oil on board
10 x 12¼
Signed lower right
Emma H. Nicholson

242. FISHERMAN; MOUNTAIN RANGE
Oil on board
13 x 6
Signed lower right
Emma H. Nicholson

243. SPRING LANDSCAPE
Oil on canvas
16 x 20
Signed lower right
Emma H. Nicholson

244. THREE FISHING VESSELS AND
ROW BOAT
Oil on board
13¼ x 6½
Not signed
Emma H. Nicholson

245. SIX FISHING BOATS AT
ANCHOR; Mt. Toro beyond
Oil on board
12 x 16
Signed lower right
Emma H. Nicholson

246. FISHING BOATS AND CABLES
WITH CATCH, MONTEREY BAY
Oil on board
12 x 16
Signed lower left
Emma H. Nicholson

247. MONTEREY CYPRESS;
SPRINGTIME
Oil on board
16 x 12
Not signed
Emma H. Nicholson

248. ROAD IN THE FOREST
Oil on board
16 x 12
Signed lower left
Emma H. Nicholson

249. FLOWERS IN THE WOODS
Oil on board
10 x 13½
Signed lower left
Emma H. Nicholson

250. TWO FISHING BOATS
Oil on board
12 x 16
Signed lower left
Emma H. Nicholson

251. TWO FISHERMEN AT WORK
ON BOAT
Oil on board
16 x 12
Not signed
Emma H. Nicholson

252. CALIFORNIA LANDSCAPE;
VALLEY AND HILLS NEAR
AROMAS
Oil on canvas, lined
10½ x 13
Signed lower right
Emma H. Nicholson

253. FISHERMEN AT PIER
Oil on unmounted canvas
10½ x 7¼
Signed lower right
Emma H. Nicholson

254. TWO BOATS IN BAY;
Snow-capped Mt. Toro beyond
Oil on board
12 x 16
Signed lower right
(On reverse of BOATS ON
SAND, KEGS IN FOREGROUND)
Emma H. Nicholson

255. BOATS ON SAND, KEGS IN
FOREGROUND
Oil on board
12 x 16
Signed lower right
(On reverse of TWO BOATS IN
BAY)
Emma H. Nicholson

256. FIVE TREES; White clouds in
background
Oil on board
16 x 12
Signed lower right "L.N."
Monterey Peninsula Museum of Art,
gift of the family of L.M. Nicholson

257. FISHING BOATS AT PIER;
Orange stack
Oil on board
12 x 16
Not signed
Mr. and Mrs. Henry P. Henrichsen

258. MONTEREY CYPRESS AT
ROAD TO SEA
Oil on board
12 x 16
Signed lower right
Mr. and Mrs. Henry P. Henrichsen

259. SAND DUNES AND CYPRESSES
Oil on board
12 x 16
Signed lower left
Mr. and Mrs. Henry P. Henrichsen

260. DUNES AND SPRING PLANTS
Oil on artist's board
6½ x 8½
Signed lower right
Mr. and Mrs. Henry P. Henrichsen

261. PINO LIGHT HOUSE AND
CYPRESS, PACIFIC GROVE
Oil on board
11 x 7¼
Signed lower right
Mr. and Mrs. Henry P. Henrichsen

262. CYPRESS AND DUNES IN SPRING
Oil on board
8½ x 10 (sight)
Signed lower center
Mr. and Mrs. Henry P. Henrichsen

263. PEBBLE BEACH MANSION (?)
Oil on canvas
11¼ x 17½
Signed lower right
Mr. and Mrs. Henry P. Henrichsen

264. EIGHT FISHERMEN AND
CATCH ABOARD
Oil on board
12 x 16
Signed lower right
Mr. and Mrs. Henry P. Henrichsen

265. MONTEREY CYPRESS
Oil on board
16 x 12
Not signed
Mr. and Mrs. Henry P. Henrichsen

266. CYPRESS AND DUNES IN SPRING
Oil on board
9½ x 13½
Signed lower right
Mr. and Mrs. Henry P. Henrichsen

267. CYPRESSES AND DUNES
Oil on board
12 x 16
Signed lower center
Mr. and Mrs. Henry P. Henrichsen

268. MONTEREY FISHING BOATS
AT ANCHOR
Oil on canvas (creased)
9¾ x 13½
Not signed
Mr. and Mrs. Henry P. Henrichsen

269. DUNES AND OCEAN
Oil on board
8 x 11½
Signed lower left
Mr. and Mrs. Henry P. Henrichsen

270. GARDEN PATH AT HOUSE
Oil on canvas
9 x 13
Signed lower right
Mr. and Mrs. Henry P. Henrichsen

271. SPRING FLOWERS ON PATH
TO BAY
Oil on canvas
9 x 11
Signed lower right "L.M.N."
Mr. and Mrs. Henry P. Henrichsen

272. BOAT AT MONTEREY,
FISHERMAN'S WHARF
Oil on board
12½ x 6
Signed lower left
Mr. and Mrs. Henry P. Henrichsen

273. TWO BLOND CHILDREN ON
BEACH
Oil on board
12 x 16
Not signed
Bill and Barbara Nicholson

274. FOUR CHILDREN PLAYING AT
BEACH
Oil on board
12 x 16
Signed lower left
Bill and Barbara Nicholson
W. A. Nelson-Rees; J. L. Coran

275. FIVE SCRUB OAKS
Oil on board
12 x 16
Signed lower right
Bill and Barbara Nicholson
W. A. Nelson-Rees; J. L. Coran

276. THREE ARCHES AT GARDEN
Oil on canvas, lined
10 x 13½
Not signed
Bill and Barbara Nicholson

277. TWO ARCHES; Tile roof at garden
Oil on canvas, lined
13½ x 10¼
Signed lower left
Bill and Barbara Nicholson

278. FLOWERS ALONG WOODED
PATH
Oil on canvas, lined
13½ x 10¼
Not signed
Bill and Barbara Nicholson

279. ROWER AMIDST LAUNCHES
Oil on board
12 x 16
Signed lower right
(On reverse of CABIN IN WOODS)
Bill and Barbara Nicholson

280. CABIN IN WOODS; Yosemite?
Oil on board
12 x 16
Signed lower left
(On reverse of ROWER AMIDST
LAUNCHES)
Bill and Barbara Nicholson

281. YUCCA AND FLOWERS AT
OCEAN
Oil on board
12½ x 10
Signed lower left
(On reverse of LARGE VESSEL
AT PIER AND OTHER BOATS)
Bill and Barbara Nicholson

282. LARGE VESSEL AT PIER AND
OTHER BOATS
Oil on board
10 x 12½
Not signed
(On reverse of YUCCA AND
FLOWERS AT OCEAN)
Bill and Barbara Nicholson

283. COUNTRY SCENE WITH
FLOWERS
Oil on board
9½ x 6½
Signed lower center
(One of a pair. Other has blue in
center)
Bill and Barbara Nicholson

284. COUNTRY SCENE WITH
FLOWERS; Blue center
Oil on board
9½ x 6¼
Not signed
(One of a pair. Other lacks blue
center)
Bill and Barbara Nicholson

285. FOREST, PIER AND BOAT;
Hawaii-like; Pebble Beach?
Oil on board
16 x 12
Signed lower right
Bill and Barbara Nicholson

286. THREE CHILDREN AND BOAT,
PACIFIC GROVE
Oil on board
13 x 8½
Signed lower right
Bill and Barbara Nicholson

287. TWO FISHING BOATS,
MONTEREY BAY
Oil on board
11¾ x 8¾
Not signed
Bill and Barbara Nicholson

288. DARK FOREST, WITH HOUSES,
SHORELINE
Oil on board
16 x 12
Signed lower right (indistinctly)
Bill and Barbara Nicholson

289. FISHERMEN IN ROW BOAT AT
PIER HOUSE
Oil on board
16 x 12
Not signed
Bill and Barbara Nicholson

290. DINGHY AND BOAT
Oil on board
13 x 6
Signed lower left
Bill and Barbara Nicholson

291. REDWOODS
Oil on board
13 x 9¾
Signed lower left
(On reverse: "Big Basin")
Bill and Barbara Nicholson

292. MONARCHS AT PACIFIC GROVE
Oil on board
12 x 16
Signed lower left
(On reverse of MONTEREY
CYPRESS AT ROCKY SHORE
LINE)
Bill and Barbara Nicholson

293. MONTEREY CYPRESS AT
ROCKY SHORE LINE
Oil on board
12 x 16
Signed lower left
(On reverse of MONARCHS AT
PACIFIC GROVE)
Bill and Barbara Nicholson

294. SEVEN BOATS AND BUOY
Oil on board
12 x 16
Not signed
(On reverse of DUNES, RED
AND YELLOW FLOWERS)
Bill and Barbara Nicholson

295. DUNES, RED AND YELLOW
FLOWERS
Oil on board
12 x 16
Signed lower right
(On reverse of SEVEN BOATS
AND BUOY)
Bill and Barbara Nicholson

296. LOADING GREEN TRUCK AT
PIER
Oil on canvas
15½ x 11
Not signed
(On reverse of BLUE APRON,
GREEN HAT AND SHIRT)
Bill and Barbara Nicholson

297. BLUE APRON, GREEN HAT
AND SHIRT
Oil on canvas
15½ x 11
Not signed
(On reverse of LOADING
GREEN TRUCK AT PIER)
Bill and Barbara Nicholson
(see comment following
no. 321)

298. OAKS WITH BUILDING
BEYOND
Oil on board
12 x 16
Signed lower right
Bill and Barbara Nicholson
W. A. Nelson-Rees; J. L. Coran

299. SEA GULLS AND PELICAN
Oil on board
11½ x 16
Signed lower right
(On reverse of MARSH AND
PARCHED HILL)
Bill and Barbara Nicholson

300. MARSH AND PARCHED HILL
Oil on board
11½ x 16
Signed lower right
(On reverse of SEA GULLS AND
PELICAN)
Bill and Barbara Nicholson

301. GULLS NEAR BOAT IN
MONTEREY BAY
Oil on board
12 x 16
Signed lower right
(On reverse of WALK TO THE
SEA)
Bill and Barbara Nicholson

302. WALK TO THE SEA
Oil on board
12 x 16
Signed lower right
(On reverse of GULLS NEAR
BOAT IN MONTEREY BAY)
Bill and Barbara Nicholson

303. OAK GROVE
Oil on board
12 x 16
Signed lower right
(On reverse of SIX MEN
MENDING NET)
Bill and Barbara Nicholson

304. SIX MEN MENDING NET; One
in green-yellow stripes
Oil on board
12 x 16
Not signed
(On reverse of OAK GROVE)
Bill and Barbara Nicholson

305. SAND DUNES WITH PURPLE
TOPS, RED FLOWERS
Oil on board (damaged)
11¾ x 16
Signed lower right
Bill and Barbara Nicholson
W. A. Nelson-Rees; J. L. Coran

306. BLUE OVERALLS AND WHITE
MOUSTACHE
Oil on canvas, lined
15½ x 11
Signed lower right "LN"
Bill and Barbara Nicholson
(see comment after no. 321)

307. GREEN TREES AND YELLOW
FLOWERS AT COAST
Oil on board
12 x 16
Signed lower right (indistinctly)
Bill and Barbara Nicholson
W. A. Nelson-Rees; J. L. Coran

308. FLOWERS AND TREES IN
GARDEN SETTING
Oil on canvas
20 x 16
Signed lower right
Bill and Barbara Nicholson

309. HOLLYHOCKS IN PACIFIC GROVE
Oil on board
13 x 6⅛
Signed lower left
Katherine E. Lake and
Ethel Wilson

PORTRAITS—PACIFIC GROVE

310. MAN ON WHARF; Blue cap,
overalls and jacket
Oil on canvas
14 x 10¼
Not signed
(On reverse of SEVEN MEN
MENDING NETS ON HILL
NEAR TREES; see no. 139)
W. A. Nelson-Rees; J. L. Coran

311. SEATED MAN, PURPLE HAT;
Cart in background
Oil on canvas laid on board
15⅝ x 11⅜
Signed lower left
W. A. Nelson-Rees; J. L. Coran

312. PORTRAIT; Man, yellow cap,
green background on white
Oil on canvas, lined
14 x 11
Signed lower right (over pencil
marks)
W. A. Nelson-Rees; J. L. Coran

313. JACK BALBOA; Portrait, man, black curly hair, green sweater, green-yellow background
Oil on canvas, lined
14 x 11
Signed lower right "L.N." "Jack Balboa" in pencil
W. A. Nelson-Rees; J. L. Coran

314. PORTRAIT; Man, yellow-brown cap, cigarette, yellow jacket (Study)
Oil on canvas, lined
14 x 11
Signed lower right "L.N."
W. A. Nelson-Rees; J. L. Coran

315. PORTRAIT OF WILGUS (Lower left in pencil); Green hair, blue jacket
Oil on canvas, lined
14½ x 10¾
Not signed
W. A. Nelson-Rees; J. L. Coran

316. PORTRAIT OF MAN (Sketch); Green tie, yellow pipe
Oil on canvas, lined
14 x 11
Not signed
W. A. Nelson-Rees; J. L. Coran

317. MAN WITH GOATEE; At boat
Oil on board
11⅜ x 9½
Signed lower right "LN"
W. A. Nelson-Rees; J. L. Coran

318. PORTRAIT; Man, blue coat and hat
Oil on canvas laid on board
14½ x 11¼
Signed lower right
W. A. Nelson-Rees; J. L. Coran

319. PLUCKING GEESE
Oil on unstretched canvas
11¼ x 15½
Not signed
(On reverse of PORTRAIT OF MAN IN BLUE)
W. A. Nelson-Rees; J. L. Coran

320. PORTRAIT OF MAN IN BLUE
Oil on unstretched canvas
15½ x 11¼
Not signed
(On reverse of PLUCKING GEESE)
W. A. Nelson-Rees; J. L. Coran

321. PORTRAIT OF MAN WITH BOW TIE AND CAP
Oil on canvas, lined
13⅞ x 11
Signed lower right "L.N."
W. A. Nelson-Rees; J. L. Coran

(Inadvertently, the portraits entitled: BLUE APRON, GREEN HAT AND SHIRT, no. 297 and BLUE OVERALLS AND WHITE MOUSTACHE, no. 306, were listed ahead of this section.)

MISCELLANEOUS WORKS

Earliest Known Studies

JUG
Pencil on paper
11¾ x 8¾
Inscribed Lillie Nicholson, upper right and bearing comment: "pretty good," right center (corners frayed)
W. A. Nelson-Rees; J. L. Coran

URN WITH THREE LEGS
Pencil on paper
11¾ x 8¾
Inscribed Lillie Nicholson upper right and bearing comment: "good drawing — but weak," right center (corners frayed)
W. A. Nelson-Rees; J. L. Coran

ALARM CLOCK AND OPEN BOOK
11¾ x 8¾
Paper. Upper half of sheet bearing printed picture and stamp of M. M. Haas Co. Publishers, San Jose; lower half constituting same picture copied in pencil (corners frayed)
Not signed
W. A. Nelson-Rees; J. L. Coran

VINE AND LEAVES
Black ink on paper
11¾ x 8¾
Dated upper left, Dec. 16, 1902
Inscribed upper right Lillie Nicholson
W. A. Nelson-Rees; J. L. Coran

The Oakland Sketch Book

A collection of unbound pencil sketches on 8½ x 11 paper utilizing both sides of each of 115 sheets, commonly having been folded twice to give eight drawing surfaces. Many are annotated, located or dated. Most are portrait sketches (see text pp. 43-44
W. A. Nelson-Rees; J. L. Coran

Unrecorded Works

Subjects generally unknown; presently unlocated

Watsonville, California;
A painting was known to have been on display in the high school

Butterfield and Butterfield Sales, San Francisco
Three paintings entitled:
MONTEREY CYPRESS
all about 12 x 16; one each, listed on:
January 8, 1979
September 25, 1978
July 17, 1978 (perhaps the same work)

Privately owned on Monterey Peninsula, in Hollister and San Francisco, thirteen or fourteen additional paintings.

San Francisco, California
One small painting lost in transport following restoration, 1979. Property of W. A. Nelson-Rees; J. L. Coran

Supplement to Catalog of Known Works

Because several works were located immediately after the original Catalog was completed, and in the event that further works are discovered and can be recorded, this open-ended supplement is appended. The author would welcome information on additional works as they are located.

322. SAND DUNES IN SPRING, PACIFIC GROVE (Her title)
Oil on board
12 x 16
Signed lower right
W. A. Nelson-Rees; J. L. Coran
Helen Saunders

323. VENETIAN SAIL BOATS
Oil on board
10¾ x 15½
Not signed
(On reverse of FARM BUILDING AND LANDSCAPE)
June K. Wright

324. FARM BUILDING AND LANDSCAPE; European
Oil on board
10¾ x 15½
Not signed
(On reverse of VENETIAN SAIL BOATS)
June K. Wright

325. LANDSCAPE WITH RIVER AND BOAT (Probably at Etaples)
Oil on board
11 x 15¼
Not signed
Similar to no. 45
June K. Wright

326. SAND DUNES AND SEA, MONTEREY PENINSULA
Oil on board
12 x 16
Signed lower right
June K. Wright

327. PIER AND OCEAN, MONTEREY
Oil on board
12 x 16
Signed lower left
June K. Wright
Emma H. Nicholson
W. A. Nelson-Rees; J. L. Coran

328. SAND DUNES, MONTEREY
Oil on board
12 x 16
Signed lower left
June K. Wright
Emma H. Nicholson

329. SAND DUNES, PACIFIC GROVE (Her title)
Oil on board
11⅝ x 15⅞
Signed lower right
(On reverse of PARIS PLAGE)
June K. Wright
Emma H. Nicholson
W. A. Nelson-Rees; J. L. Coran

330. PARIS PLAGE (Her title); Beach with wading figures and umbrella
Oil on board
11⅝ x 15⅞
Signed lower right
(On reverse of SAND DUNES, PACIFIC GROVE)
June K. Wright
Emma H. Nicholson
W. A. Nelson-Rees; J. L. Coran

331. MONTEREY CYPRESS — 17 MILE DRIVE (Her title)
Oil on board
12 x 16
Signed lower left
(Title and artist's address on reverse)
Estate of Commander and Mrs. Rocker
Tim and Lynn Mason
W. A. Nelson-Rees; J. L. Coran

332. CYPRESS POINT
Oil on canvas
8 x 16
Signed lower left
Witherspoon Galleries
Mary Lu and Tom Lowe

333. MONTEREY CYPRESS TREES FROM 17 MILE DRIVE (Her title)
Oil on canvas
12 x 16
Signed lower left
Witherspoon Galleries
Mary Lu and Tom Lowe

334. ROCKY COAST AND WHITE FOAM
Oil on board
12½ x 10
Signed lower right
Emma H. Nicholson
W. A. Nelson-Rees; J. L. Coran

335. IMPRESSION OF BOATS AT PIER
Oil on board
12 x 16
Signed lower left
Emma H. Nicholson
W. A. Nelson-Rees; J. L. Coran